1984

LEONARDO
THE
ARTIST

ANNA MARIA BRIZIO
UNIVERSITÀ STATALE OF MILAN

MARIA VITTORIA BRUGNOLI
UNIVERSITY OF ROME

ANDRÉ CHASTEL
COLLÈGE DE FRANCE, PARIS

LEONARDO
THE
ARTIST

McGRAW-HILL BOOK COMPANY
New York St. Louis San Francisco

A McGraw-Hill Co-Publication

Copyright © 1980 by McGraw-Hill
Book Company (UK) Limited,
Maidenhead, England. All rights
reserved. No part of this publication
may be reproduced, stored in a retrieval
system, or transmitted in any form or
by any means, electronic, mechanical,
photocopying, recording, or otherwise,
without the prior written permission
of the publisher.

Library of Congress Cataloging in
Publication Data:
Leonardo the Artist by Anna Maria
Brizio, Maria Vittoria Brugnoli,
André Chastel.
Essays originally published in
The Unknown Leonardo, edited by
Ladislao Reti, with additional
illustrations. Includes index.

 1. Leonardo da Vinci, 1452–1519.
 I. Brizio, Anna Maria.
 II. Brugnoli, Maria Vittoria.
 III. Chastel, André, 1912–
 IV. Reti, Ladislao.
 Unknown Leonardo.
 V. Title.

N 6923.L33 L46 759.5 80-10253

ISBN 0-07-007931-5

Printed in Czechoslovakia

PERUSE ME, O READER,
IF YOU FIND DELIGHT
IN MY WORK,
SINCE THIS PROFESSION
VERY SELDOM
RETURNS TO THIS WORLD,
AND THE
PERSEVERANCE TO PURSUE IT
AND TO INVENT
SUCH THINGS ANEW
IS FOUND IN FEW PEOPLE.
AND COME MEN,
TO SEE THE WONDERS
WHICH MAY BE DISCOVERED
IN NATURE
BY SUCH STUDIES

MADRID I 6r

CONTENTS

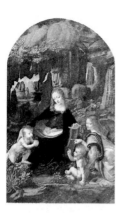

BY ANNA MARIA BRIZIO
A study of the works of the most flourishing
period of Leonardo's artistic creation: the
Mona Lisa, the *Virgin of the Rocks,* the *Last
Supper,* the *Sala delle Asse,* the *Cartoon of
St. Anne,* the *Battle of Anghiari.*

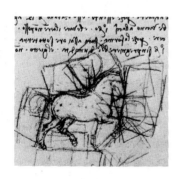

BY MARIA VITTORIA BRUGNOLI
THE EQUESTRIAN STATUE The extraordinary his-
tory of Leonardo's abortive attempt to con-
struct an enormous bronze statue for the Duke
of Milan and the revolutionary casting method
he developed.

BY ANDRE CHASTEL
A discussion of the notes, observations, criti-
cisms, and reflections of Leonardo that estab-
lish him as a supremely important theoretician
of art, and the works in which his theories are
applied.

FROM THE RENAISSANCE TO THE TWENTIETH CENTURY THE WORK OF LEONARDO TRANSCENDS TIME

INTRODUCTION

Leonardo's childhood home, in Anchiano near Vinci.

"A grandson of mine was born,
son of Ser Piero my son, on April 15,
Saturday at three o'clock in the night.
His name was Lionardo."

He was like a man who awoke too early in the darkness, while the others were all still asleep," wrote Sigmund Freud. Many of Leonardo's notebooks, folios, writings, and drawings disappeared into that darkness, and it is their rediscovery and reassemblage that is gradually illuminating the enigma of this genius, gradually extending our knowledge of the unknown Leonardo.

Two of Leonardo's notebooks, having been officially lost since 1830, were rediscovered in the Biblioteca Nacional, Madrid, in 1965. McGraw-Hill and Taurus Ediciones were authorized to publish a five-volume facsimile edition of these Madrid Codices, with transcription, translation, and commentary by the late Vincian scholar Ladislao Reti. On the basis of the wealth of new material in the notebooks, a group of the world's leading Vincians contributed to a reassessment of the many facets of Leonardo's genius, a large-scale collection of essays, which was published as *The Unknown Leonardo*. The present book on Leonardo the artist, like the companion volumes that will follow concerning his scientific studies and his diverse inventions, is reprinted in smaller format from that voluminous work.

The first chapter, "The Painter," by Anna Maria Brizio, concerns Leonardo's thoughts about painting, which he considered as "really science and the legitimate daughter of nature." Science and painting were directly connected for Leonardo, as Brizio discusses in terms of the *Last Supper*. His studies on physics and mechanics and his knowledge of perspective and painting merge there to produce a timelessly beautiful work of art. The Madrid Codices also establish time and technical references for the destroyed masterpiece, the *Battle of Anghiari*. Beyond all this, however, the codices are in themselves works of art, with their quick sketches, detailed studies and mechanical designs.

"The Sculptor," by Maria Vittoria Brugnoli, describes the folios in Codex Madrid II dealing with the Sforza monument. This 23-foot-high bronze equestrian statue was an ongoing project for Leonardo throughout the 20 years he remained in Milan at the court of Lodovico; political vicissitudes prevented its realization. Leonardo formulated for the monument a new and sophisticated casting process, designed to eliminate the problems of the centuries-old lost-wax process. The new process was not to be tried out for almost 200 years, but it seems clear that later sculptors must have been aware of Leonardo's writings and that the new process that he invented here revolutionized casting methods.

"The Teacher," the chapter by André Chastel on the treatise on painting, discusses the notes in Codex Madrid II that would later be elaborated in Libro A, with his principles of painting and notes on anatomy, visual perception, color range, perspective, and light reflections, or *lustro*. Chastel's chapter indicates Leonardo's broad view of the entire field of painting.

+ 1

Havendo, Signor mio Ill.mo, visto e considerato hormai ad sufficientia le prove di tutti quelli che si reputano maestri e compositori de instrumenti bellici: et che le inventione e operatione di dicti instrumenti non sono niente aliene dal comune uso: mi exforzerò non derogando a nessuno altro farmi intendere da V. Ex.tia aprendo a quella li secreti mei: e apresso offerendoli ad ogni suo piacimento i tempi oportuni operare al effetto de ca tutte quelle cose che sub brevità saranno qui di sotto notate: e anchora in molte più secondo le occurrentie de diversi casi &c.

1. Ho modi de ponti leggerissimi e forti e ad altri ad portare facilissimamente: E cum quelli seguire e alcuna volta fuggire li inimici e altri securi e offensibili da foco e battaglia: facili e comodi da levare e ponere. Et modi de ardere e disfare quelli de inimici.

2. So in la obsidione de una terra togliere via l'acqua de fossi: e fare infiniti ponti ghatti e scale et altri istrumenti pertinenti ad dicta expeditione.

3. Item se per alteza de argine o per forteza de loco e di sito non si potesse in la obsidione de una terra usare lo officio de le bombarde: ho modi di ruinare omni forte o altra forterezza se già non fusse fondata in su el saxo &c.

4. Ho anchora modi de bombarde comodissime e facile ad portare: Et cum quelle buttare minuti sassi a similitudine quasi di tempesta: e cum el fumo di quella dando grande spavento al inimico cum grave suo danno e confusione &c.

5. Et quando accadesse essere in mare ho modi de molti istrumenti actissimi da offende e defende: e navili che faranno resistentia al trarre de omni grossissima bombarda: e polve e fumi.

6. Item ho modi per cave e vie secrete e distorte fatte senza alcuno strepito per venire ad uno certo e disegnato loco ancora che bisognasse passare sotto fossi o alcuno fiume.

7. Item farò carri coperti securi e inoffensibili e quali intrando intra li inimici cum sue artiglierie non è sì grande multitudine di gente d'arme che non rompessino Et dietro a questi poteranno seguire fanterie assai illesi e senza alcuno impedimento.

8. Item occorrendo di bisogno farò bombarde mortari et passavolanti di bellissime e utile forme fora del comune uso.

9. Dove mancasse la operatione de le bombarde componerò briccole mangani trabuchi e altri istrumenti di mirabile efficacia e fora del usato: Et insomma secondo la varietà de casi componerò varie e infinite cose da offende e da defende.

10. In tempo di pace credo satisfare benissimo ad paragone de omni altro in architectura in compositione di edificii e publici e privati: e in conducere acqua da uno loco ad uno altro.

Item conducerò in sculptura di marmore di bronzo e di terra: similiter in pictura ciò che si possa fare ad paragone de omni altro e sia chi vole.

Anchora si poterà dare opera al cavallo di bronzo che sarà gloria immortale e eterno honore de la felice memoria del Signore vostro patre e de la inclita casa Sforzesca.

Et se alcuna de le sopra dicte cose a alcuno paressino impossibile e infactibile mi offero paratissimo ad farne experimento in el parco vostro o in qual loco piacerà a Vostra Ex.tia: alla quale humilmente quanto più posso me recomando &c.

Most Illustrious Lord, Having now sufficiently considered the specimens of all those who proclaim themselves skilled contrivers of instruments of war, and that the invention and operation of the said instruments are nothing different from those in common use: I shall endeavour, without prejudice to any one else, to explain myself to your Excellency, showing your Lordship my secrets, and then offering them to your best pleasure and approbation to work with effect at opportune moments on all those things which, in part, shall be briefly noted below.

1 *I have a sort of extremely light and strong bridges, adapted to be most easily carried, and with them you may pursue, and at any time flee from the enemy: and others, secure and indestructible by fire and battle, easy and convenient to lift and place. Also methods of burning and destroying those of the enemy.*

2 *I know how, when a place is besieged, to take the water out of the trenches, and make endless variety of bridges, and covered ways and ladders, and other machines pertaining to such expeditions.*

3 *Item. If, by reason of the height of the banks, or the strength of the place and its position, it is impossible, when besieging a place, to avail oneself of the plan of bombardment, I have methods for destroying every rock or other fortress, even if it were founded on a rock, &c.*

4 *Again, I have kinds of mortars; most convenient and easy to carry; and with these I can fling small stones almost resembling a storm; and with the smoke of these cause great terror to the enemy, to his great detriment and confusion.*

9 *And if the fight should be at sea I have kinds of many machines most efficient for offence and defence; and vessels which will resist the attack of the largest guns and powder and fumes.*

5 *Item. I have means by secret and tortuous mines and ways, made without noise, to reach a designated [spot], even if it were needed to pass under a trench or a river.*

6 *Item. I will make covered chariots, safe and unattackable, which, entering among the enemy with their artillery, there is no body of men so great but they would break them. And behind these, infantry could follow quite unhurt and without any hindrance.*

7 *Item. In case of need I will make big guns, mortars, and light ordnance of fine and useful forms, out of the common type.*

8 *Where the operation of bombardment might fail, I would contrive catapults, mangonels, trabocchi, and other machines of marvellous efficacy and not in common use. And in short, according to the variety of cases, I can contrive various and endless means of offence and defence.*

10 *In time of peace I believe I can give perfect satisfaction and to the equal of any other in architecture and the composition of buildings public and private; and in guiding water from one place to another.*

Item. I can carry out sculpture in marble, bronze, or clay, and also I can do in painting whatever may be done, as well as any other, be he who he may.

Again, the bronze horse may be taken in hand, which is to be to the immortal glory and eternal honour of the prince your father of happy memory, and of the illustrious house of Sforza.

And if any of the above-named things seem to any one to be impossible or not feasible, I am most ready to make the experiment in your park, or in whatever place may please your Excellency — to whom I commend myself with the utmost humility, &c.

"Drawn by my ardent desire,
impatient to see
the great abundance of
strange forms
created by that artificer,
Nature, I wandered
for some time
among the shadowed rocks.
I came to the mouth
of a huge cave
before which I stopped
for a moment, stupefied
by such an unknown thing....
After a time there arose
in me both fear
and desire –
fear of the dark and
menacing cave;
desire to see
whether it contained
some marvelous thing."

Arundel 1551 R

Self-portrait of Leonardo (lived 1452–1519).

Preceding page: The famous letter of self-recommendation from Leonardo da Vinci to the Duke of Milan, Lodovico Sforza. Though the surviving document is not in Leonardo's handwriting, its authenticity is unquestioned.
Translation by Jean-Paul Richter, from The Literary Works of Leonardo da Vinci, *3d ed. (London: Phaidon, 1970).*

10

THE
UNIVERSAL
GENIUS

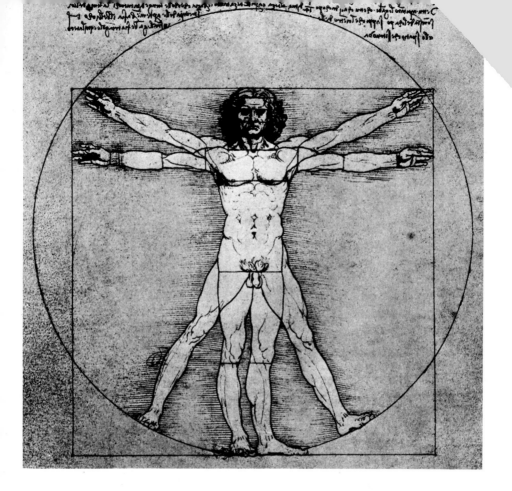

In his letter applying for an appointment to serve the Duke of Milan, Lodovico Sforza (see pages 8–9), Leonardo claims to possess an awe-inspiring range of skills. His notebooks, preserved in the Madrid Codices and elsewhere, more than bear out the claim. These documents reveal a man whose curiosity seemed boundless, who could explore painting techniques as well as hydraulic engineering, comparative and human anatomy (as in the sketch shown above, a study of proportions in the human figure), musical instruments, optics and botany, massive sculpture and machines of all kinds.

Many of his designs and concepts were too advanced for his contemporaries; they were finally appreciated approximately 200 years after his death.

This introduction offers a brief overview of some of the specific aspects of this universal genius who seemed to personify the term "Renaissance man."

Among the major innovations of the Renaissance, and no doubt the most far-reaching in its impact, was the rehabilitation or rediscovery of nature as a positive entity. Indeed, according to one Vincian scholar, the Renaissance made nature its religion, "sought God in nature." For Leonardo, rational knowledge was based on the experience of the senses: man's role was to observe nature as attentively and completely as possible. Observation, the learning of nature's forms and nature's laws, became the basis of his manifold intellectual activities and provided their underlying unity. His studies of mechanics, optics, water, animals, his engineering designs, his sketches, writings, and paintings all derive from this common source. He defended his right and indeed his duty to devote long hours to the study of nature, even on holy days, despite all criticism.

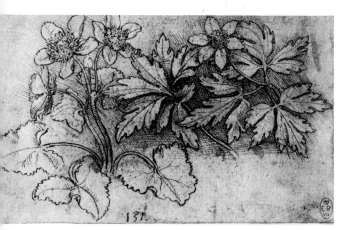

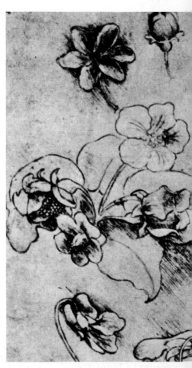

As if prophesying the modern ecological movement, Leonardo foresaw, he said, a time when "the great forests will be deprived of their trees" and when men would "deal out death, affliction, labors, terrors, and banishment to every living thing." His sketches of the plant and animal world suggest his love and respect for the works of nature, whether he was preparing studies for a larger painting or (as with the bird sketch above) observing nature.

THE NATURAL SCIENCES

In his unceasing quest for truth, Leonardo explored every branch of the sciences known to his age and proved in many respects to be far ahead of his time in his precise observations, his striving for sound methodology and measurement, and the value he placed on empirical truth. "No human investigation," he wrote, "can be called true science without going through mathematical tests...the sciences which begin and end in the mind cannot be considered to contain truth, because such discourses lack experience, without which nothing reveals itself with certainty."

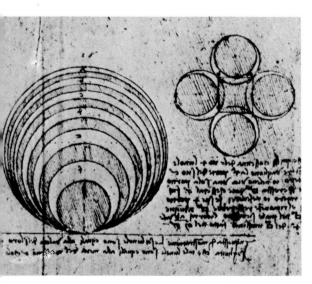

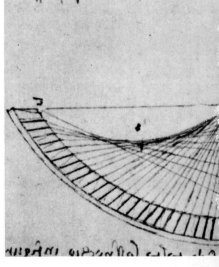

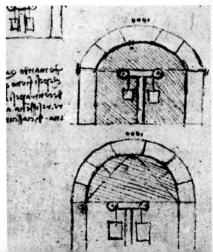

Leonardo's 12 concentric circles, above, create mathematical proportion – the six white crescents together have an area equal to half that of the largest circle – and a maze of receding crescent moons.

The sketch at center analyzes the reflection of luminous rays from the concave surface of a mirror.

Arches used as structural elements often collapsed and no one, not even Leonardo, was quite sure why. In these drawings he attempts to establish rules for the stresses that cause failure in arches.

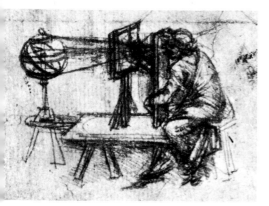

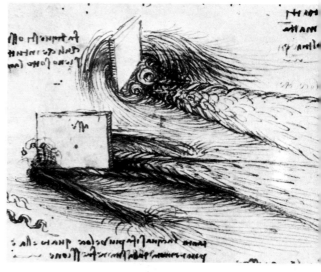

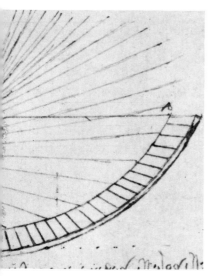

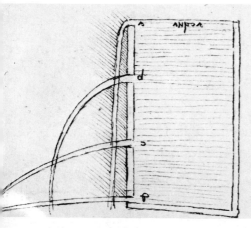

The perspectograph, wr ... signed to aid the artist, ... Albrecht Dürer. It permitt... and draw from a fixed posi... spective – a subject of great... mathematically inclined Leo... a piece of glass as large as aet of royal folio paper and set this firmly between your eye and the thing you want to draw, then place yourself at a distance of two-thirds of an ell from the glass, fixing your head with a mechanism so that you cannot move it at all. Then shut or cover one eye."

The movement and the behavior of liquid particles impelled by a motion different from that of the mass in which they are immersed, and the formation of fluid threads, for a long time formed one of the main subjects of the hydraulic case histories studied by Leonardo.

Left: A study, from Madrid Codex I, 134 verso, of water falling at four different heights from a container. Leonardo concludes that the "power" or energy is the same for each waterfall, a basic theorem of modern hydrodynamics.

17

"I can do in painting whatever may be done, as well as any other, be he who he may." Trained as a painter in the studio of Andrea Verrocchio, Leonardo created several masterpieces throughout a long career, first in Florence, then in Milan, Rome, and Amboise. His notebooks in the Madrid Codices, written in the period 1491–1505, are contemporaneous with the paintings of the *Sala delle Asse*, the *Last Supper*, the *Virgin and Child with St. Anne, Battle of Anghiari,* and the *Mona Lisa,* all discussed in this volume. The *Annunciation,* below, gives an idea of the character of his earlier painting-style, before the prime period.

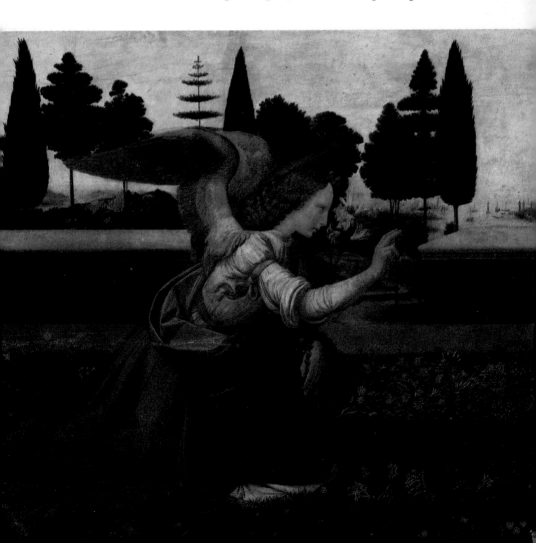

"Though human ingenuity may make various inventions which, by the help of various machines, answer the same end, it will never devise invention more beautiful, nor more simple, nor more to the purpose, than nature does, because in her inventions nothing is wanting and nothing is superfluous, and she needs no counterpoise when she makes limbs proper for motion in the bodies of animals. But she puts into them the soul of the body, which forms them…"

ɔks offer something not found in the marvelous finished paintings: glimpses of Leonardo's inventive, imaginative mind at work, and at play. He not only explored and solved puzzles and problems of a scientific nature, but created, at least on paper, contraptions and gadgets of many kinds. Although the bicycle sketch on this page is not attributed to Leonardo's own hand, its presence in the notebooks suggests that it may have been a copy that someone drew of a sketch of his, or of a machine he had constructed. The ingenuity and far-sightedness of this genius encourage the speculation that the bicycle, "invented" centuries after Leonardo's death, may be much older – may indeed be an invention of his own.

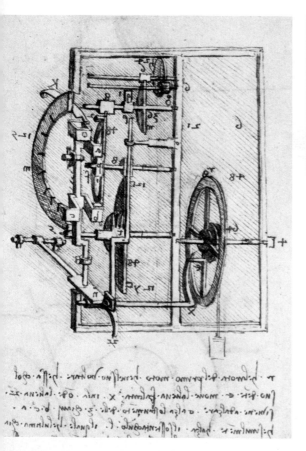

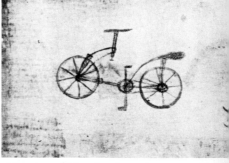

The incredible drawing above recently found on the reverse side of folio 48 recto-b (now numbered 133 verso) in Codex Atlanticus was obviously drawn by a youthful hand. However, this may be a copy of someone else's work, presumably Leonardo's.

Other inventions: At left, a weight-driven clock-work complete with striking mechanism. Opposite above, study for a helicopter-like flying machine.

Below, an unidentified device for transmitting power. The turning of the two screws moves an arm – somewhat akin to a clock hand – around the circle formed by the concave screws.

Overleaf: Leonardo's map of the city of Imola.

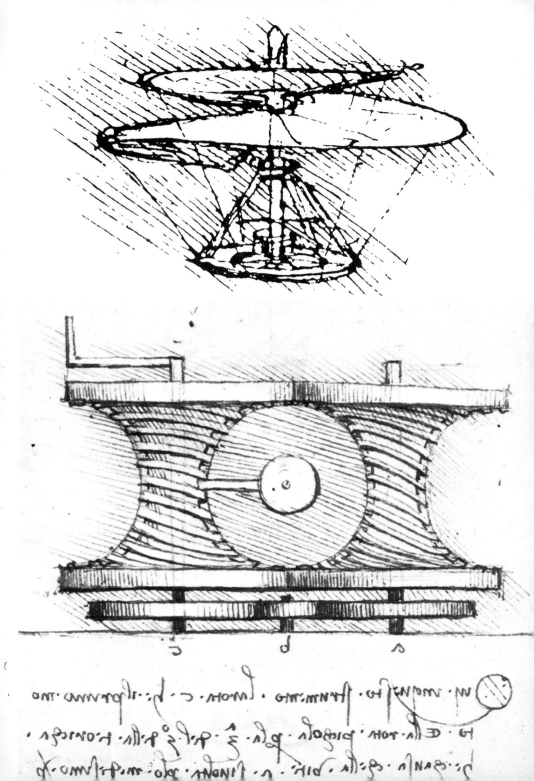

ant· ammastis··l··il·primo·uno
lo·dellotor·pingola·pla·z·del·g·della·fronega·
disiemli·egilla·pir·v·linoni·soo·medisimo·d

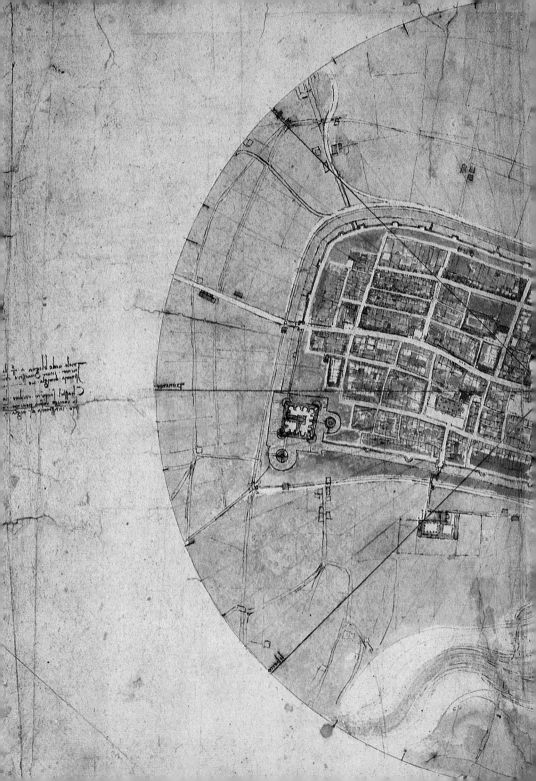

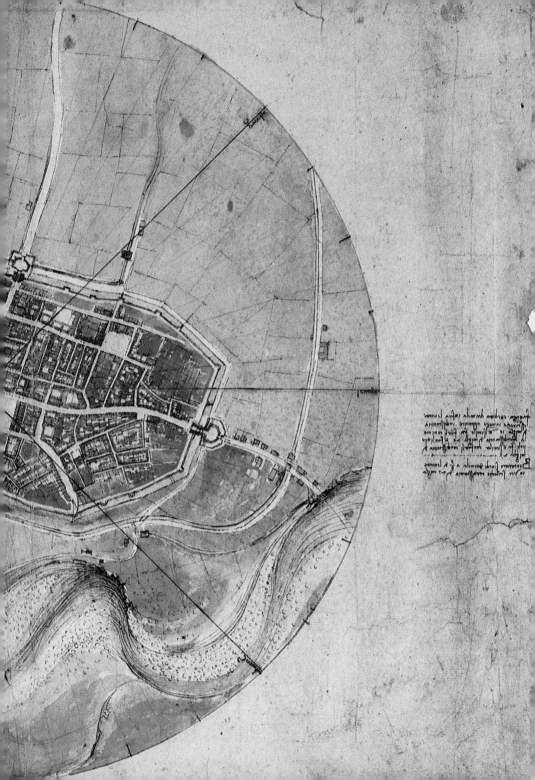

ARCHITECTURE

Leonardo is not generally accorded much attention as a theoretical architect; professionally he was more closely associated (as the following pages show) with military, defensive architecture. And yet several sketches in the different codices demonstrate his strong interest in architectural problems in general. His painting of the town plan of Imola (preceding pages) suggests one facet of this interest; there is even more evidence of his concern with fundamental structural elements such as the arch and the dome. Leonardo devoted many sketches and notes to the problem of arch stability, and split the arch into individual wedge-shaped stones. His calculations show that he was close to realizing the modern method of determining the horizontal thrust in the arch. The arch was of course important to the design of the dome, which was another of Leonardo's preferred subjects.

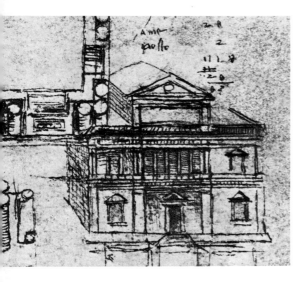

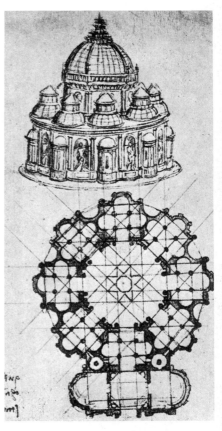

Samples of Leonardo's architectural sketches, reproduced on these pages, suggest the seriousness of his interest in architecture. Above is a drawing of the façade, floor plan, and various details for the design of an aristocratic mansion.

The central-plan church, right, presents a vast dome surrounded by eight radiating chapels. Such designs, as opposed to the plan based on the elongated Latin cross, reflect a geometric shape derived from the circle.

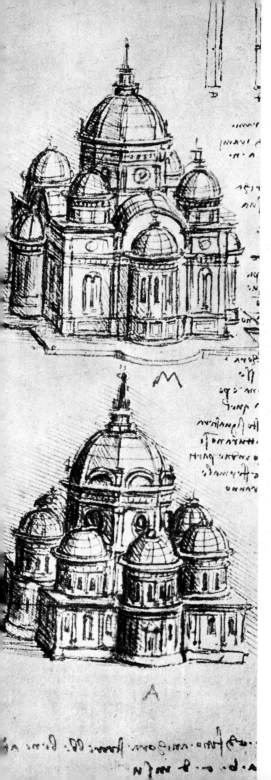

In sketch after sketch, the notebooks reveal a preoccupation with architecture both as artistic expression and as a technical problem. The domed central-plan design, as in the two examples at left, afforded many variations on a basic theme: a model with four small domes (above), which stresses squareness; and a ring of eight small cupolas (below), which make the essentially square floor plan seem circular. The two sketches are also based on entirely different scales, the dome in the lower example being much larger (particularly in proportion to the whole structure) than that in the upper sketch. To Leonardo and his contemporaries, the dome was an enormous technical challenge.

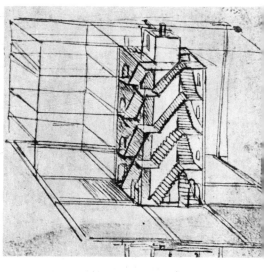

The sketch directly above, far less finished than the others, is a rather fanciful idea for a quadruple staircase built around a central shaft. It is obvious that it was more carefully executed in the lower sections and became vaguer, as if drawn at a constantly increasing tempo, in the upper stories. (The roughness of the sketch offers a strong contrast to his finely worked-out, minutely detailed and colored town plan of Imola, pp. 22–23.)

25

111,537

MACHINES AND WEAPONRY

Nearly five centuries have passed since Leonardo recorded his thoughts and designs for machines intended to simplify the routine tasks that he saw being performed around him. His purpose was to have the work done more quickly and easily, while maintaining standards of uniformity and precision. As adviser to heads of state, military commanders, nobles, and estate managers, he acted as designer, engineer, architect, geologist, anatomist, master of ordnance, and seer.

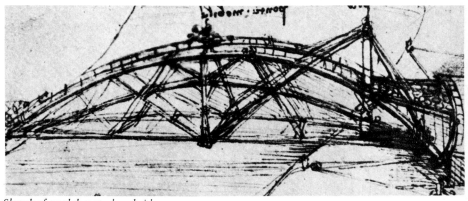

Sketch of an elaborate drawbridge.

Having visualized a mechanical solution to a problem he sketched the parts and the assembly, noted the working directions, assigned to himself further tasks for study, and moved on to other problems. Yet no solution was ever adequate, for he would return later to some similar device to accomplish the same task by using different parts or a different assembly of parts.

Nine-tenths of the Madrid Codices are devoted to technological subjects; they supplement Leonardo's other mechanical studies and provide the scholar of today with the most comprehensive corpus of Renaissance technology.

An inventory of Leonardo's machines divides them into the major categories of those for improving mechanical work (and therefore productive) and those for military application (and therefore destructive). The cities of Florence, Milan, and Venice were then among the most active in establishing patterns for mills, pumps, winches, wagons, tools, and the weapons of war, and the design of these intrigued Leonardo. He haunted the wrights and masters of forge and mill, observed design change and progress, and recorded them in his notebooks.

Overleaf:
This delightful contraption is a kind of crossbow, a machine gun that enables Leonardo's archer – suspended inside the big treadwheel – to keep the arrows flying at a rapid pace. The archer's comrades furnish the foot power to turn the wheel under the protection of a planked shield Leonardo has provided for them. At right, a preliminary sketch shows wheel and bowmen in whirling action.

Left:

Fire is shown raining down: use of bombardments in defense of a bastion. Firepower replaced the use of hot tar in defensive combat in Leonardo's time.

In his famous letter to Lodovico Sforza, Leonardo had promised new and secret instruments of war. He sketched the technique shown in the drawing below – a warrior's hand-borne lance is augmented by two others affixed to his horse's saddle – only a year or so after his arrival at the Sforza court in Milan.

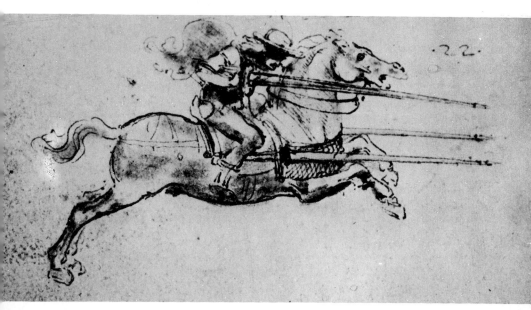

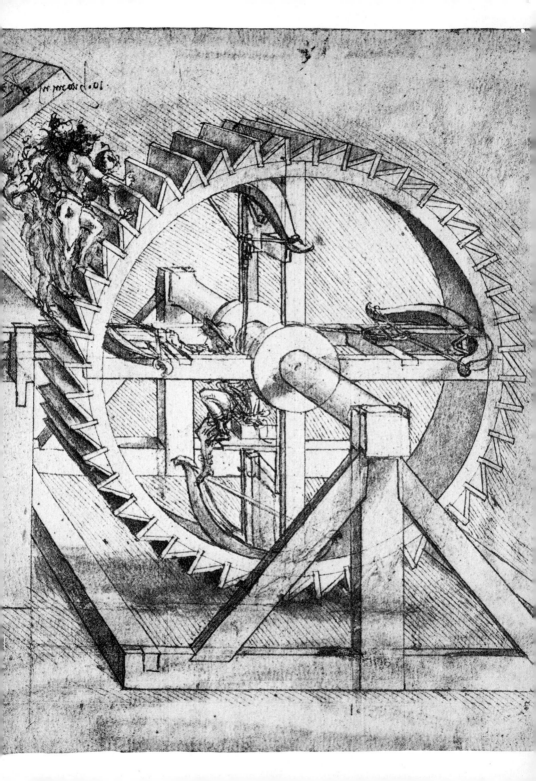

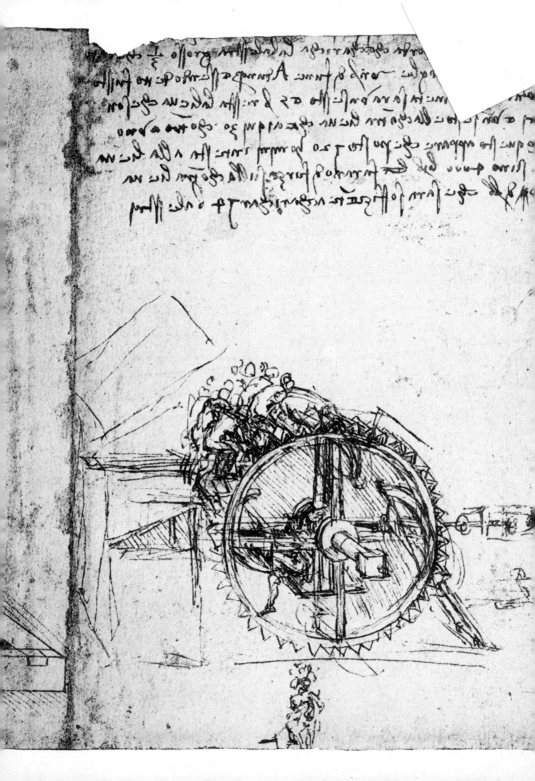

FORTIFICATION DESIGNS

The diverse aspects of Leonardo's genius are examined more fully in separate chapters of this three-volume series (beginning, in the present volume, with Leonardo the artist). The final element to be considered in this general introduction is Leonardo's design of defensive fortifications – which is but one aspect of his work in military architecture. He not only mastered conventional techniques and proposed daring new solutions in fortress design, as illustrated here, but made exhaustive studies of other ambitious projects. One of these was the Florentines' plan to divert the course of the River Arno in order to keep the people of Pisa from receiving supplies by river from the sea coast. The plan was finally abandoned as unworkable.

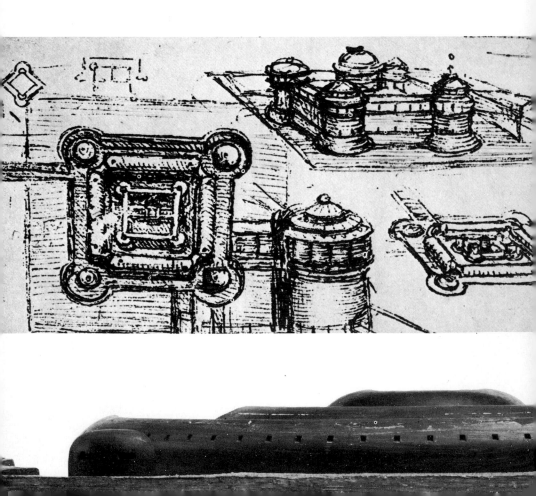

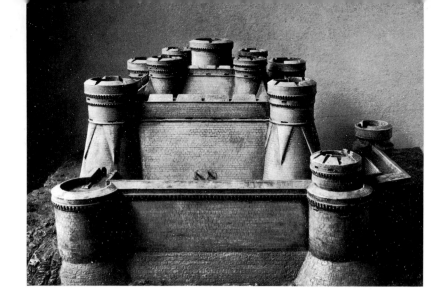

Leonardo's fortress designs represent a considerable evolution from the conventional to the boldly inventive. The typical fortress of his day, as in the model reconstruction above, was a square structure within two surrounding walls which were turreted and slightly angled. This design prevailed during the development of heavy firepower.

The sketches at left show Leonardo's continued exploration of this standard fortress design, with ground plan, elevation sketches, and various details. In planning the new fortress works for Piombino, he paid particular attention to an art that was then relatively new – efficient organization of the firepower that was revolutionizing warfare. But the most daring of his innovations was the design of a fortress that was to be circular rather than square. This stronghold (which he never took farther than the sketching stage) consisted of a series of concentric fortifications, each protected by a moat. Particularly dramatic in its effect is the side view of his fortress (bottom left), in a reconstruction model assembled long after his time. The structure's ominous streamlined profile foreshadows fortifications of later centuries.

"... where nature finishes
producing its shapes, there man begins
with natural things and with the help
of nature itself, to create infinite
varieties of shapes."

THE PAINTER

ANNA MARIA BRIZIO

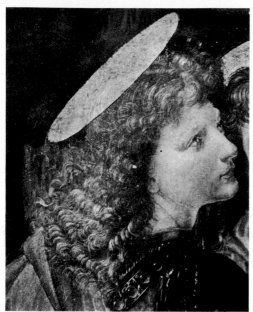

This head is a detail from the kneeling angel painted by the young Leonardo in Andrea Verrocchio's Baptism of Christ. *He was then an apprentice in the famed workshop of Verrocchio in Florence.*

The extraordinary economic and cultural expansion of Florence throughout the 14th and 15th centuries had resulted in such an accumulation of artistic potential in the city, in so many *botteghe* of art, and in such widespread fame for the artists of Florence that for some time Florentine artists had been called upon everywhere to present their work. Beginning in the 1480s, however, the succession of exoduses took on an impressive rhythm: a veritable diaspora spread throughout Italy. It is my belief that in these years a specific policy of Lorenzo de' Medici was developed to foster a purposeful exportation of artistic labor. By sending Florentine artists to the various Italian courts, Lorenzo the Magnificent gained both an opportunity for exchanges and a source of prestige.

In 1482 Botticelli, Ghirlandaio, Perugino, Piero di Cosimo, and Cosimo Rosselli were summoned to Rome by Sixtus IV to decorate the Sistine Chapel. The work completed, they went back to Florence. But in the meantime Verrocchio too had received commissions from both Rome and Venice. Leaving Lorenzo di Credi in charge of his *bottega* in Florence, Verrocchio moved to Venice in order to carry out on the spot the equestrian monument to Bartolommeo

Colleoni, and it was there that he died in 1488. The *botteghe* of Verrocchio and Antonio Pollaiuolo were the most important in Florence at that time. Pollaiuolo also moved away from Florence with his brother Piero in 1489, summoned by Innocent VIII to Rome, where he remained until his death. During the same years, approximately from 1488 to 1493, Filippino Lippi was also in Rome, working on the frescoes for the Carafa Chapel in the Church of Santa Maria sopra Minerva – and the list could go on.

The transfer of Leonardo from Florence to Milan in 1482 takes place at precisely this historical moment and in this climate. The information given by the Anonimo Gaddiano and later taken up by Vasari, that Leonardo was sent to Lodovico il Moro in Milan by Lorenzo the Magnificent – bringing with him a silver *lira* in the form of a horse's skull – is usually thought to savor an episode of a novel. Yet it can be better seen as a significant indication of the role played by Lorenzo the Magnificent in promoting a great exportation of works of art and Florentine artists all over Italy.

The consequences for the artistic future of Florence were serious and irreversible; the city never again regained the role of artistic capital which it had held for 200 years. But the effects of this diffusion upon the development of Italian art were extraordinary. Until then the regional schools of art had greatly differed among themselves, but with the exodus of the 1480s a process began that was to lead, in the space of less than half a century, to the formation of an art that could thenceforth claim without reservations to be "Italian." Where politicians had failed to create the Italian nation, the artists succeeded – and so completely as to place the stamp of the Italian Renaissance on all European art for more than two centuries.

I am convinced that the first act of this grand process took place in Milan, in the period of almost 20 years that Bramante and Leonardo remained in continuous contact with one another at the court of Lodovico il Moro. Both came from central Italy, from two centers of very high culture, related by common roots and a similar direction: Bramante from Urbino in the Marches, Leonardo from the most important Florentine *bottega* of the time. In Milan, both Leonardo and Bramante found themselves plunged into a milieu that, by its language, its social and political system, and its customs and mentality, was very different from their places of origin. Judging by the consequences, this change must have provided them with a strong stimulus that led to a profound renewal of interests, to new problems, new solutions, and a new

course for their artistic activity. In Leonardo's case, the activity was not only artistic: for we cannot speak of Leonardo as a painter and ignore, or even pass lightly over, the fundamental question of the relationship between art and science in his work.

Italian Renaissance art enjoyed a prestige that cannot be matched by any other artistic epoch, because in that period Italian artists, for a favored moment, not only were very great as artists but also represented the spearhead of the culture of their day. In a 1938 essay, which has not had the echo it deserved among the historians of art, W. M. Ivins unreservedly declares that "the most important thing that happened during the Renaissance was the emergence of ideas which led to the rationalization of sight." [1] Not the fall of Constantinople, not the discovery of America, neither the Reformation nor the Counter Reformation, insists Ivins, but the rationalization of sight was the most significant event of the Renaissance. And the rationalization of sight was the work, first and foremost, of the Florentine artists, through the invention of perspective.

By a long academic tradition we have become accustomed to consider perspective as a device for the correct formal representation of the proportions of figures and as a measure of space. But this is only the fossilized sediment of what perspective originally was. The Florentine artists of the Renaissance cast away all the interminable case studies of medieval optics and retained only the basic data of visual angles. To the angulation of the visual rays, with its vertex in the eye, the Euclidean principle of proportional triangles was applied. By cutting the visual angle at any point whatsoever with a perpendicular line it became possible to measure with a constant rule any image that fell at any given distance from the vertex.

This system was perfected by the Florentine artists Brunelleschi and Alberti and was applied at first to painting. It made possible a composition that was calculable in constant terms of proportions and measures and was thus delivered from traditional empiricism: it was precisely the rationalization of sight. But with perspective the artists created an instrument that was to acquire great value even in the scientific field, because it made possible the measurement of dimensions and distances in exact and constant terms. The perspective of the Renaissance was the first link in the chain that, as Ivins affirms, was to lead to Kepler and Desargues, and on to the projective geometry of Monge and Poncelet. It is at this point that art and science in the Renaissance meet. And on this path, art leads the way.

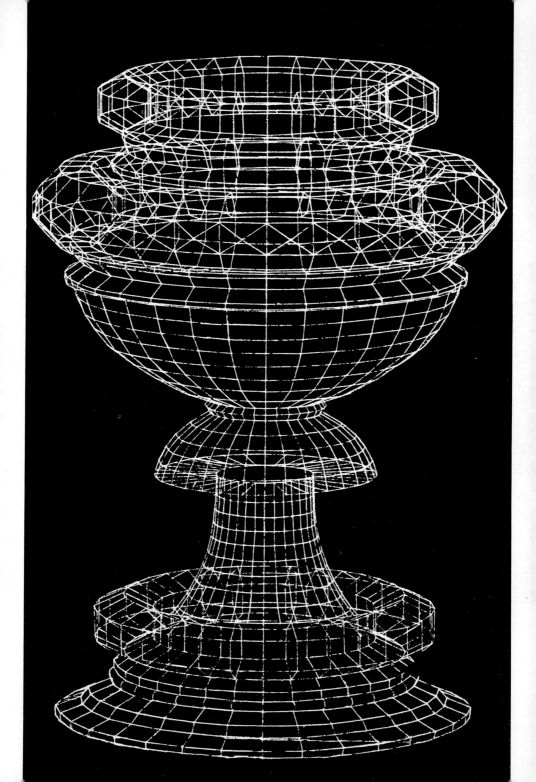

The precise proportions of this drawing of a chalice reflect the two complementary leading themes of Florentine art of the first half of the Quattrocento: *linear perspective, which gives a new rational definition of space according to the constant ratios of proportional measurements; and the construction of solid bodies, the volumes of* which become regular geometrical bodies complementary to the geometrical and proportional dividing of the empty spaces. The drawing is attributed to Paolo Uccello (recently also to Piero della Francesca) and is kept in the Gallery of the Uffizi in Florence.

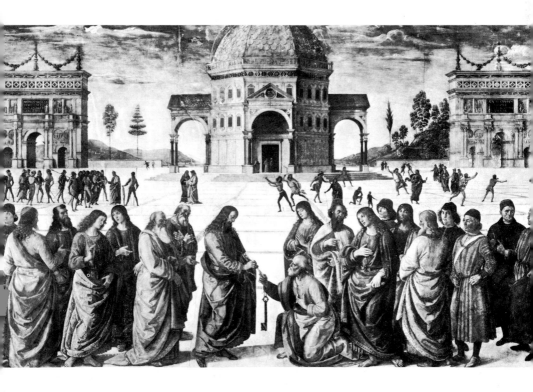

In Perugino's fresco Consignment of the Keys to St. Peter, *painted in the Sistine Chapel of the Vatican, the perspective method is not merely a demonstration, but is used to represent the scene more naturally and narratively more clearly. The charac-* ters are placed in the immediate foreground; the buildings in the background recede into the distance, and have a geometric regularity and a symmetrical arrangement. The young Perugino was an apprentice with Leonardo in Verrocchio's workshop.

Along with perspective the other great concept that dominated Renaissance art was that of the imitation of nature. This is not to be interpreted in the petty 19th-century sense of the reproduction of the external, epidermic appearances of nature. For the Florentine artists of the 15th century the imitation of nature was a "subtle speculation": they felt an injunction to investigate the laws of nature and according to these same laws to create, reproducing the creative process of nature itself (below). "The artist disputes and competes with nature," Leonardo wrote. It is understandable how such an attitude brought with it the inclination to look with fresh interest into all natural phenomena, an inclination that became one of the most revolutionary and innovative factors in all the culture of the time. Placed at the center of this process is Leonardo, who pushed it so far forward as to provoke the separation of the two fields, "art" and "science."

In our own times, dominated as they are by scientific and technological interests, the whole of Leonardo's scientific and technical activity, so brilliant and so extraordinarily precursory, is increasingly attracting the attention of scholars. The rediscovery of the Madrid Codices – especially the extraordinary Codex

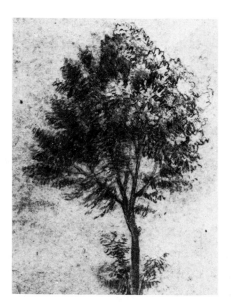

This drawing of a locust tree (Windsor 12431 verso), also datable around 1505, is another example of Leonardo's organic vis-

ion of nature. The variations of light and shade depend on the thickness of the tree's foliage. From the beginning Leonardo had a

Madrid I, with its splendid series of drawings of machines of exceptional demonstrative clarity – provides new subject matter that reinforces the tendency for Leonardo's scientific interests to overshadow his concerns as an artist. For these reasons, in this volume which is intended to accompany the publication of the Madrid Codices, it seems all the more appropriate to establish clearly that the starting point for Leonardo was painting.

Let us discard every academic interpretation of painting and bring it back more to its essence: the force of image, the power of expression through images, of creating the image most pertinent and meaningful of that which the mind "dictates within and formulates." There is no doubt that Leonardo expresses himself prevalently by images and figures, that for him drawing is the fundamental instrument of analysis and of representation; but that also, his investigations predominantly begin with visual data. "If you look down on painting," he wrote, "which is the only imitator of all the works manifest in nature, you will certainly be looking down on a subtle invention, which with philosophic and subtle speculation considers all the qualities of forms. . . . This is really science and the legitimate daughter of nature." Leonardo does

very lively taste for landscape. The detail above, taken from the Uffizi Annunciation, painted when he was young, shows the opening into the distant landscape which the dark trees repel even further in the clearness of the far horizon.

not see painting as the repetition of the forms of nature, but considers man himself as a force of nature continuing its work and creation. "Where nature finishes producing its shapes, there man begins, with natural things and with the help of nature itself, to create infinite varieties of shapes." For Leonardo, painting – and drawing, which is the fastest kind of painting – is the most direct and effective means of "mental discourse" in every field.

In Leonardo himself this aspect becomes more evident and acquires increasing development and urgency as the years go by. It begins to assert itself a few years after his arrival in Milan.

When he came to Milan, Leonardo must have been deeply struck by the difference of atmosphere in Lombardy, where medieval guild systems were

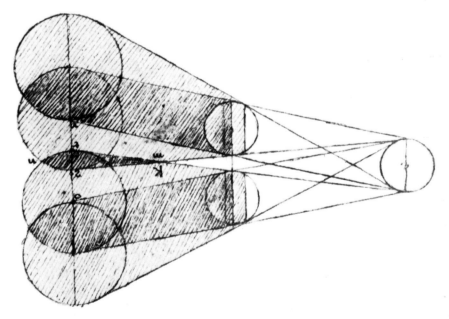

The study of rays, their angles and paths and the countless figures they compose was for Leonardo the vehicle in studying optics, perspective, photometry and in general all the phenomena of impact.

The drawing reproduced here, from Ms. C. folio 14 recto, is a study of photometry: the spherical body on the right represents the source of light; the spheres of growing dimensions that follow each other on their path represent opaque bodies – "ombroso" – which intercept the luminous rays. The drawing demonstrates graphically the number of intercepted rays and as a consequence the greater or lesser density of the shade behind the intercepting bodies.

still in force and where painters, sculptors, and architects were still regarded as craftsmen. At the same time, he must have become fully aware of the new and extraordinary instruments with which his Florentine education had provided him, and of the possibilities of applications in every field that they opened to him. From the time of his arrival in Milan his interests and his experiments tended to branch out in every direction. But the admirable advances in technical and scientific pursuits did not distract him from the art of painting. Scientific attitude and artistic vision are never in antithesis in Leonardo; on the contrary, the one springs incessantly from the other.

The period to which the Madrid Codices date – from 1491 to 1505, to stick literally to the extreme dates that are written there – corresponds to the central and most fertile period of Leonardo's activity. During that time he developed his studies on force, motion, and weight, on the "mechanical elements," on the motion of water and air, on hydraulics, on the flight of birds, and on anatomy, along with a succession of discoveries and inventions extraordinarily ingenious and anticipatory. And during that time he executed his main works of art in painting: the *Last Supper,* the *Cartoon of St. Anne,* the *Gioconda,* the *Battle of Anghiari* – works that, to take up again Vasari's famous phrase concerning the frescoes of Masaccio at the Carmine church, "changed the face of painting."

The first important commission that Leonardo received in Milan was the task entrusted to him and to the De Predis brothers by the Brethren of the Conception on April 25, 1483, of painting the altarpiece for the Chapel of San Francesco il Grande. And it is useful to remember the Louvre *Virgin of the Rocks* – which is all that remains of Leonardo's work on the altarpiece – in establishing a limit of comparison in order to measure the distance that separates the *Last Supper* from Leonardo's previous artistic production.

The *Virgin of the Rocks* (p. 47) still bears so strongly the stamp of the Florentine style that Vincian scholars of authority have been able to subscribe to the opinion that it was carried out in Florence and that Leonardo brought it with him when he moved to Milan and then thought of using it for the altarpiece for the Brethren of the Conception. The supposition is unsustainable, and difficult to believe for anyone who knows how slow and unreliable Leonardo was in carrying out a work, even when bound by a contract. We can imagine what the situation would be like when no obligations existed! But above all we already see in the *Virgin of the Rocks,* in spite of its Florentine stylistic

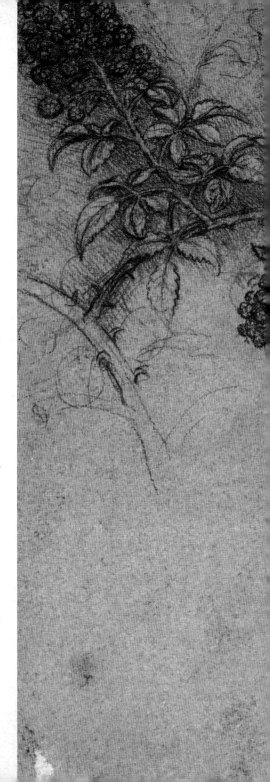

In contrast to the previous figures, this red-chalk drawing emphasizes the different way Leonardo has of looking at nature. He had detached himself from the Florentine school and around 1505 arrived at this vision, much more animated and organic. Emerging from the abstract geometrical space of the Florentine perspective, Leonardo takes into consideration all the atmospheric and optical effects of the physical space. This shoot of blackberry, lush with fruit and leaves, is not isolated from its environment to receive a more accurate formal definition, but acquires intense vitality directly from its immersion in the atmospheric environment which surrounds it, by the use of irregular and mobile effects of light and shadow.

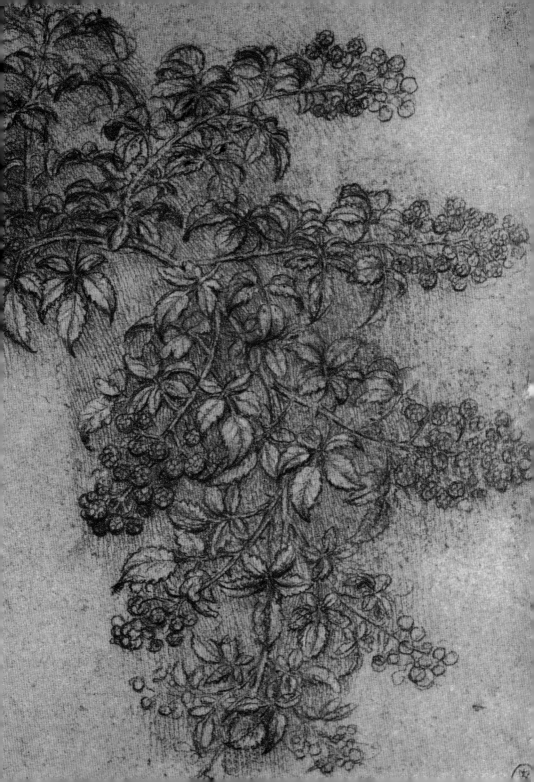

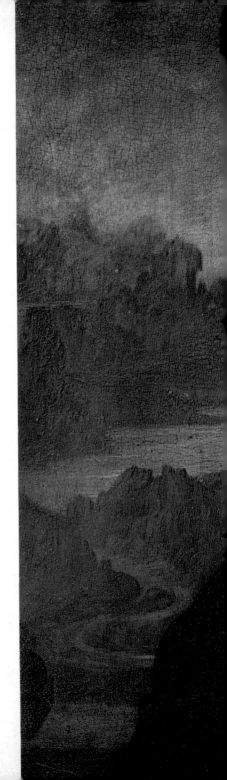

During the years of the Battle of Anghiari
Leonardo painted the Mona Lisa, *one of
the most famous paintings of the world.
"Caught Leonardo painting for Francesco
del Giocondo," writes Vasari, "the portrait
of Mona Lisa, his wife . . . , work which is
today with King Francis of France." A new
direction that departed from the lucid cer-
tainty of the foregoing Florentine human-
ism is seen in the famous "smile of the*
Mona Lisa," *which has mysterious and
ambiguous psychological depths. One can
also feel this new awareness of Leonardo in
the background landscape. It is not a real
landscape, but a kind of geological composi-
tion in which, in the stratification of the
rocks, in the shape of the waters, the tem-
poral stratification of centuries past is
reflected.* LOUVRE, PARIS

44

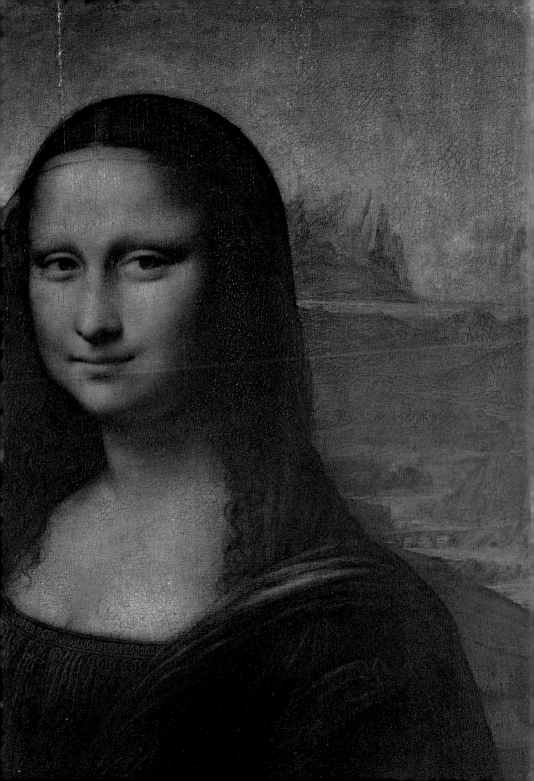

features, a sum of new thoughts. Its iconography is linked with the theme of the Conception, which was the object of a special cult in Milan.

It is too often forgotten – accustomed as we are to seeing the *Virgin of the Rocks* on the wall of a museum and to contemplating it for its own sake – that this painting was only a small part of the whole. The altar of the Chapel

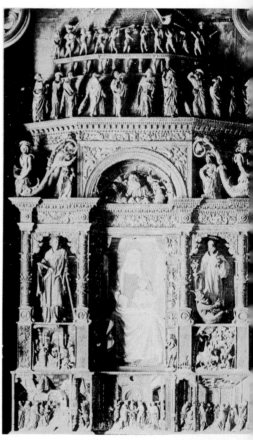

The big wooden altar (commissioned by the Brethren of the Conception to Giacomo del Maino, on April 18, 1480, for their chapel in San Francesco il Grande) for which Leonardo and the De Predis brothers should have successively executed paintings, is now lost. The altar represented here, however, still in existence in the Church of the Virgin Mary in San Lorenzo at Morbegno in Valtellina, can give an idea of it. It is also a large wooden construction: the sculptures, which prevail, alternate with paintings. The top is in the shape of a small half-dome on which stands a statue of the Virgin. Below her, around the cornice, we see the apostles, turned upwards, and in between her and the apostles a garland of cherubs. On the panels, left empty and flat, the Virgin with the Child on the throne and other figures were painted by Gaudenzio Ferrari and Fermo Stella, exactly as Leonardo and the De Predis brothers contributed paintings to the altarpiece of San Francesco. Both groups of painters also had the duty of coloring and gilding all the carved parts.

of San Francesco il Grande was a monumental sculptured altar. According to the custom in Lombardy at that time, the contract charged Leonardo and the De Predis brothers first of all to color and to gild the sculptured wooden part; and then to fill in the panels left free of carvings with a larger scene dedicated to the Virgin, flanked on each side by four angels playing instruments and singing. To think of Leonardo working like a simple artisan on the gilding

and coloring of these frames, columns, and reliefs fits in badly with the image that has been built up of him over the centuries. It is still more difficult to think of the *Virgin of the Rocks* forming part of that great complex swarming with reliefs and glittering with gold. It sounds like a challenge for Leonardo; and it reveals an unshakable determination not to withdraw from his own artistic intention that he carried out for an altarpiece of this kind a painting

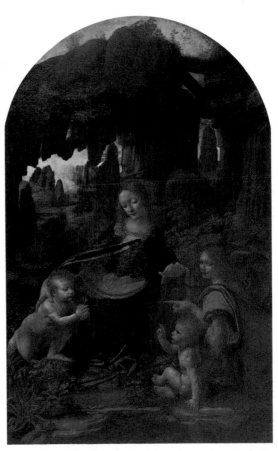

This is the first version of the Virgin of the Rocks, *entirely by Leonardo's own hand, painted for the altarpiece of the Brethren of the Conception in San Francesco il Grande in Milan. The contract was made on April 25, 1483. It is uncertain whether this first (Louvre) version has ever been placed in the wooden altar. The second version (National Gallery, London) comes directly from the altar of San Francesco; it is a work executed with the collaboration of helpers. One should notice here the novelty of such a composition at that time: in the great mountain of carved wood that was Giacomo del Maino's archaic altar, Leonardo boldly put a composition full of shadows and imbued with depth. It must have seemed to actually deepen into a mysteriously complex grotto, foreshadowed in the semi-obscurity.*

so overflowing with shadows, so subtle and mysterious, as the *Virgin of the Rocks*. It must surely have seemed like a dark cave submerged in that brilliant golden mass of frames, columns, and reliefs.

The composition of the painting is perspectively outlined in depth. The figures are slightly drawn back from the foreground towards the rear; the open arms

of the Virgin forming a pyramid and the angel's finger pointing to St. John seem to explore and scan space in various directions; and everything is surrounded by shade and light – a very sparing light that is used to draw from the shade, with soft gradations, the relief of the forms.

Just over 10 years later, the relationship between figures and space in the *Last Supper* (p. 53) is profoundly changed; the growth of the figures is striking. Table and apostles are placed in front, at the forelimit of the room where the scene takes place, which rapidly shrinks behind them; the figures are dominating and seem to come forth into the *real* space of the refectory. Leonardo has carried out a profound change in the lucid perspective of the Brunelleschi–Alberti tradition by means of a minimal but fundamental shift.

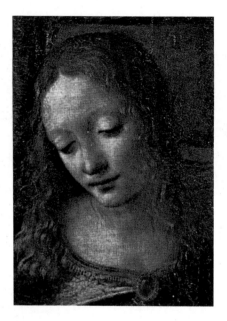 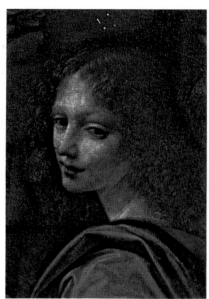

Instead of considering the eye as an abstract point, simply the apex of the visual pyramid, he has made it coincide with the real eye of the spectator, creating the illusion that painted space and real space interpenetrate and continue in each other. In this way the spectator finds himself taken illusorily inside pictorial fiction, and a new, far more dynamic and dramatic relationship is established between him and the persons represented, resulting in a much stronger effect of reality and participation. At the other end of the long room of the refectory, the *Crucifixion* of Montorfano, executed in fresco in exactly

the same years (it bears the date 1495) and facing the *Last Supper*
like a tapestry stuck to the wall.

The studies on physics and mechanics that Leonardo had pursued
widening extent since his arrival in Milan overflowed into his pictorial vision
and shook the foundations of Florentine 15th-century figurative art. This is
a very important turning point in painting; it is brought about by Leonardo,
and the first great accomplishment to come from it is the *Last Supper*.

Every element of the pictorial composition is involved in this profound transfor-
mation. The attitudes and gestures not only represent physical motions but
also are the expression of the emotional reactions, each one individually charac-

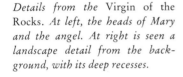

Details from the Virgin of the
Rocks. *At left, the heads of Mary
and the angel. At right is seen a
landscape detail from the back-
ground, with its deep recesses.*

terized, of the apostles to the words of Christ: "One of you will betray me."
The motions of the hands, so carefully studied and expressed, are worthy
of note. This most dramatic moment of the Supper had been represented
in the traditional way in the previous Florentine versions of the 15th century.
But the traditional gesture of Christ offering the bread to Judas, a gesture
of denunciation and accusation, has been omitted by Leonardo; and the meaning
and resonance of Christ's words are grasped only in the reactions of the apostles,
which spread like a chain from one end of the table to the other. One apostle

At right, large detail from the Florence *Virgin of the Rocks,* now in the Louvre, *showing the Christ child on the left, accompanied by Mary, an angel, and the infant John the Baptist.*

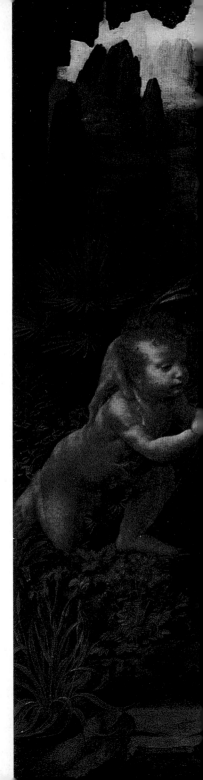

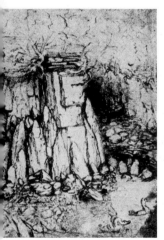 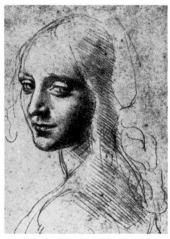

These two sketches by Leonardo are believed to have been studies for the Virgin of the Rocks. *The drawing of rocks and water birds (left) is now in the Windsor Royal Library; the angel's head, in the Biblioteca Reale, Turin.*

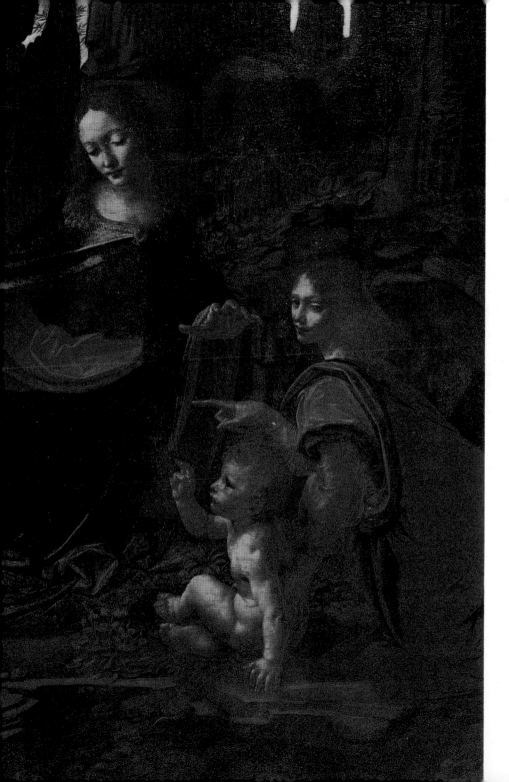

quickly rises from his seat, another leans forward towards Christ, another draws back. The apostles draw closer together in lively groups which, as the figures separate and join up, leave irregular intervals among them. The traditional symmetrical arrangement of the apostles on the sides of Christ, sitting motionless along the table, is dramatically stirred up and brought to life in Leonardo's version. It is a new way of composing, much more complex in articulations and connections.

The only one who remains outside the wave of emotional turmoil, immersed in the liberating depths of meditation and acceptance, is the Christ, who lowers his glance and gently opens his arms, brushing the tablecloth lightly with his hands. His gesture creates space and a pause around him; it isolates him and makes him the center of the scene. The triple window that opens behind him onto a distant scene accentuates further his central position.

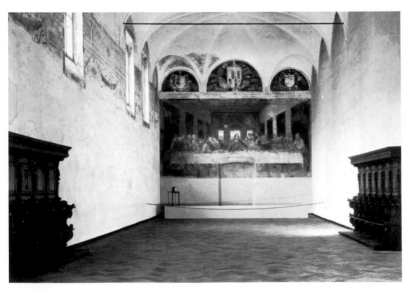

The setting of the Last Supper, *in the refectory of Santa Maria delle Grazie, was conceived by Leonardo so as to seem to be an extension of the real space of the room itself; and the light in the painting has been made to coincide with the real light that comes from the windows on the left. Leonardo here combined fiction and reality to create a unique effect. The crescent-shaped lunettes above the fresco correspond to a Vincian conception, but they are too badly preserved for us to judge whether he actually painted them.*

And he said, Go into the city to
such a man, and say unto him, The Master
saith, My time is at hand; I will keep the
passover at thy house with my disciples.
And the disciples did as Jesus had
appointed them; and they made ready the
passover.
Now when the even was come, he sat down
with the twelve.
And as they did eat, he said, Verily
I say unto you, that one of you shall
betray me.
And they were exceeding sorrowful, and
began every one of them to say unto
him, Lord, is it I? MATTHEW 26:17-22

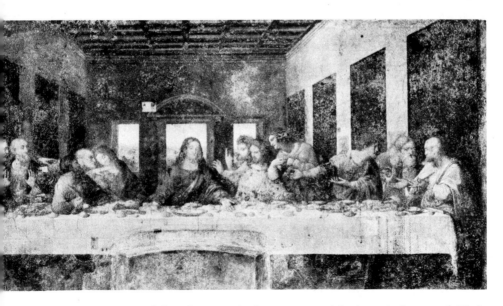

The Last Supper *and the tribune conceived by Bramante for the church are the two works that from Milan initiated the new course of Italian art in the 1500s. A little more than 10 years after the* Virgin of the Rocks, *the relation between space and figures is profoundly changed. The persons represented dominate the foreground. Their gestures and attitudes not only show physical motions but also express their emotional reactions, each one individually characterized, to the words of Christ, "One of you will betray me."*

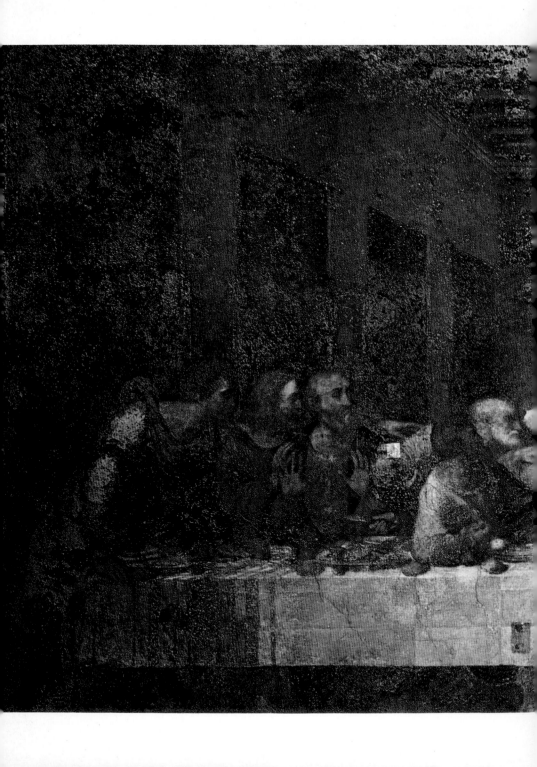

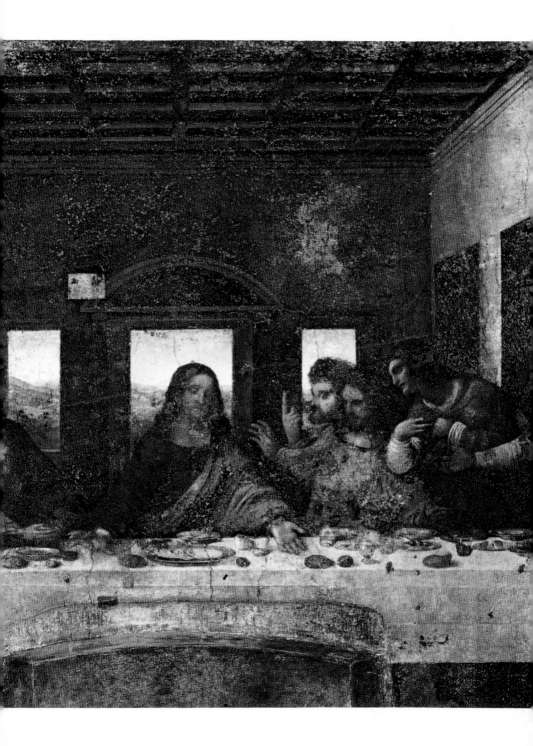

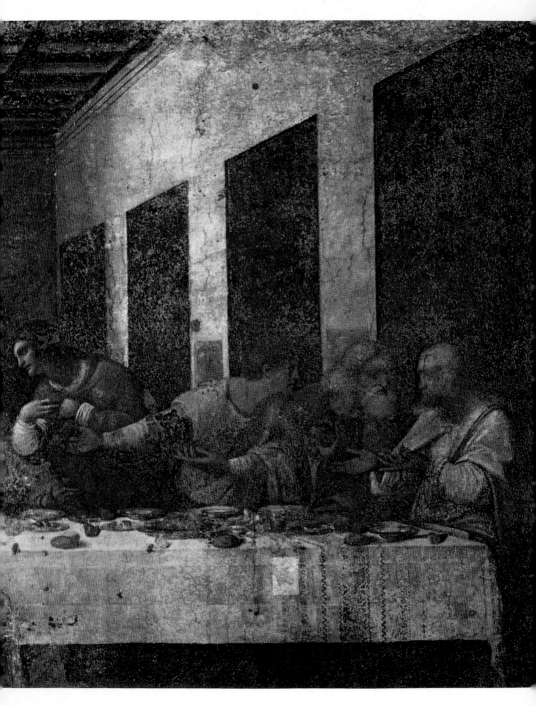

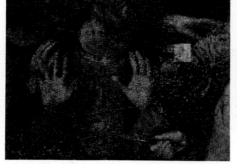

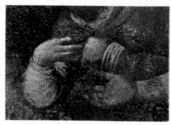

Peter.

Bartholomew. *Both hands from James the Lesser and Andrew; Peter's hand holding a knife.*

Judas. *Judas and John.*

Christ.

Thomas and James the Greater.

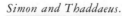

Philip and Matthew.

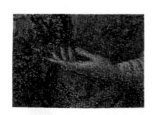

Matthew. *Simon and Thaddaeus.*

Details of the hands of the apostles and of Christ in the **Last Supper.** *The gestures and movements are particularly expressive of each individual's state of mind and emotional reaction. The hands are placed so that they serve as an element of the composition, linking each group of three apostles.*

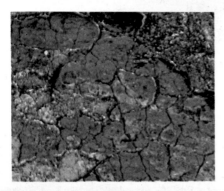

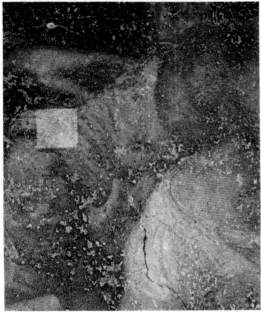

The close-up photos on this page, all from the area around Judas's hand holding the purse, were taken during the restoration of the Last Supper, after the Second World War. Early in the war, only a careful encasement of sandbags prevented its outright destruction by a bomb that exploded a few yards away. Flake by flake the peeling paint was reattached to the wall. Then the heavy encrustations of previous repaintings were removed. In the detail at center there appears a small rectangle that was left to indicate the condition of the surface before the new restoration. In the top picture, the restoration of the blue area reveals the boldness of Leonardo's original colors.

On the opposite page, in a detail from the Last Supper, the central figure of the Christ sits alone against the luminous background of the window that opens on a distant landscape. It is immediately apparent that he is the protagonist. The axial position of his bust, in contrast to the accentuated displacement of the busts of the apostles, the wide gesture of the arms, his eyes looking down and inward, all indicate the infinite distance between Christ and his supreme acceptance, and the wave of emotions, so much more passionately human, which strikes and agitates the groups of apostles.

But the light which illuminates the scene as a whole does not come from the triple window in the background; it comes transversely from the left; Leonardo has intentionally made it coincide with the actual lighting of the room, coming from the row of open windows on the wall to the left. This coincidence of source of light, together with the artifice of perspective, leads to a fusion of fiction and reality.

The *Last Supper,* as soon as it appeared, struck contemporaries as a powerful revelation of reality. The traditional way of painting was suddenly a thing of the past; from here begins a new trend in painting. All contemporary sources speak of the *Last Supper* in admiring terms. The King of France would have liked to have it taken down from the wall and transported to France, and only the difficulty of the task, according to what Vasari writes, "saw to it that His Majesty took his desire with him, and it [the painting] was left to the Milanese." In the course of the two or three following decades the copies of it multiplied in France, in Italy, and in Flanders. When the future King

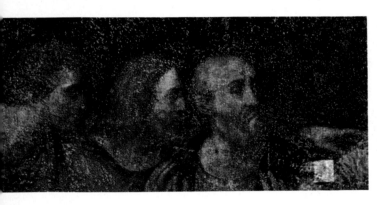

Bartholomew, James the Lesser, and Andrew.

"Another shrugs his shoulders up to his ears, making a mouth of astonishment." "Another speaks into his neighbor's ear and the listener turns to him"
Judas, Peter, and John.

Henry II of France married Caterina de' Medici in 1533, Pope Clement VII, himself one of the Medici, sent to the newlyweds as a wedding gift a unicorn magnificently and preciously worked, a masterpiece of jewelry; and King Francis I returned the compliment with a piece of tapestry reproducing Leonardo's *Last Supper,* which has recently been put on view in the Vatican Picture Gallery. Woven into the rich edge that frames it are the monogram and the royal devices of France. The alterations that Leonardo's composition underwent in the tapestry show how difficult it was to grasp the noble, very lofty essence of the Leonardesque conception. The tapestry is far more ornate and flaunts in the background a very complicated "modern" French architecture.

Like the hands, but in a more open and direct manner, the apostles' heads are all masterpieces of psychological and physiognomical investigation. The details reproduced here, in the traditional grouping by three, clearly demonstrate the mode of composition of the Last Supper, *which seems* to arise naturally from the gestures and impetuous movements caused by the words of Christ. These various dynamic groupings enhance the interaction within each group and cause the strongest energy to surge towards the center of the fresco.

Judas, Peter, and John.

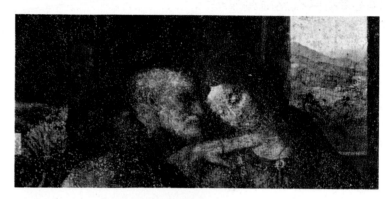

Thomas, James the Greater, and Philip.

"Another . . . turns with stern brows to his companion."
"Another leans forward to see the speaker. . . ."

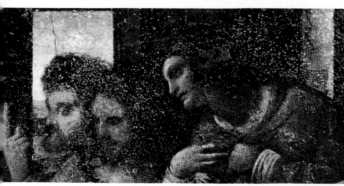

Matthew, Simon, and Thaddaeus.

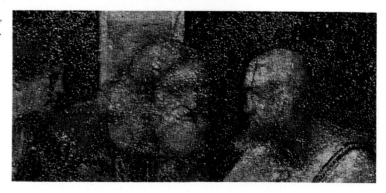

During the years he devoted to the *Last Supper,* Leonardo was working for Lodovico il Moro at the Sforza Castle. Of his paintings in the *camerini* and the *saletta negra,* of which the sources speak, nothing remains. Only the famous decoration of the *Sala delle Asse* (pp. 66–67) survives. Although repainted, indeed largely remade, during the restorations made by Luca Beltrami in 1901 and 1902, it still produces a grandiose and engaging effect. Basing his work on the few remaining traces of the original, Beltrami completed the decoration's motifs by repeating them until he had covered the whole vault. The hall is situated in the tower on the northeast corner of the castle and on account

All the subtle hidden correspondences between the groups of apostles and the simple but monumental relation between figures and space that exist in Leonardo's Last Supper *are blatantly ignored in this faded and torn copy by an unknown artist of the 16th century. Also omitted are the windows, which in Leonardo's original open the enclosed space towards a vast, luminous distance behind Christ.*

of its position must have been used especially in the summer season. This circumstance was, I think, of some importance in suggesting to Leonardo the choice of the decorative arboreal motif. It must also have been suggested to him by the persistence in Lombardy of this kind of motif, typically Gothic in its origin but still widely used throughout the north in the late 15th century. Gothic art had always favored a varied, intricate, and fantastic wealth of plants, leaves, flowers, hedges, and espaliers as a background for tapestries and murals of large dimensions, as well as for short illuminated pages. In Leonardo's day frescoes such as those of Bembo and of Michelino da Besozzo and their circles,

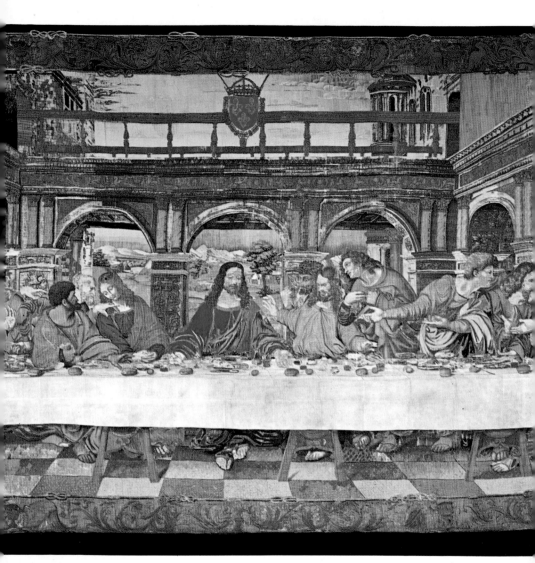

This large tapestry, representing the Last Supper *and now exhibited in the Picture Gallery of the Vatican, was given by King Francis I of France to Pope Clement VII in 1533 in exchange for a gift from the Pope on the occasion of the dauphin's wedding, the future Henry II, to the niece of Clement VII, Caterina de' Medici. The tapestry had been woven in Flanders on the king's order.*

The powerful simplicity of Leonardo's Last Supper *is replaced by a richer setting, ignoring the great significance of Leonardo's composition entirely impregnated by the dramatic action of the persons represented. The sumptuous architecture, however, in which this Last Supper takes place documents the strongly italianized style prevalent at the Court of Francis I.*

which still exist in the Milanese palace and in the Rocca d'Angera of the Borromei, must have been quite usual in the mansions and castles of the duchy of Milan. Thus, to choose that motif for the *Sala delle Asse* was an affirmation of the community of origins and traditions that linked the duke to the duchy. The linkage was made explicit in the great tablets that hang from the ropes twisted around the branches and display coats of arms and inscriptions celebrating Lodovico il Moro.

But the Gothic muralists had drawn up their vegetal backgrounds, their espaliers of greenery along the walls, like tapestry or cloth, on the surface. Leonardo

Although the Sforza Castle in Milan has, on occasions, been greatly remodeled, the ancient ground plans and the large proportions of the apartments around the ducal courtyard and the courtyard of the Rocchetta remain. Some interior rooms, including, at the northeast corner, the famous Sala delle Asse *where Leonardo executed the great arboreal decoration, also remain unaltered.*

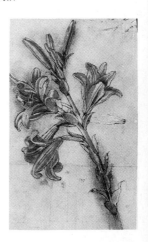

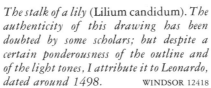

The stalk of a lily (Lilium candidum). *The authenticity of this drawing has been doubted by some scholars; but despite a certain ponderousness of the outline and of the light tones, I attribute it to Leonardo, dated around 1498.* WINDSOR 12418

imagines an arboreal cap curved like a vault, which illusorily substitutes itself for the true vault, opening the space of the room, and uncovering it by simulating the open sky beyond the entanglement of the branches.

Huge branches bent by force intertwine, describing a plurality of acute intersecting arches which compose designs very similar to those that cornices and fretwork

make at the top of large Gothic windows. Leonardo must have observed and studied them with keen interest, attracted by their complexity and their ornate magnificence. In the *Sala delle Asse,* to the already complicated interlacings of branches are added those of a rope – a single continuous rope – which twines and untwines in recurrent knots and meanders, insinuating itself and re-emerging among the foliage. Leonardo's innate taste for labyrinthine complications finds in the vault of the *Sala delle Asse* a monumental development. Yet everything has been architecturally structured. In the spaces between the branches appears the blue of the sky. Originally the effect of opening and of brightness must have been much stronger and far more illusory. An example

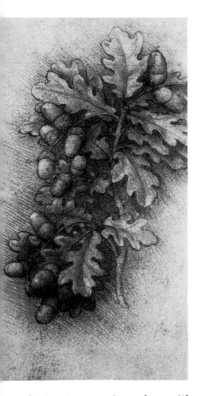

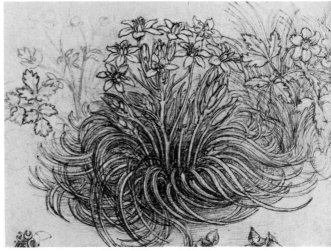

A cluster of Star of Bethlehem (Ornithogalum umbellatum) *in red chalk. Beautiful volutes are traced by the revolving movement of the long leaves.*

Red-chalk drawing of a spray of oak leaves with cluster of acorns. To be noted is the mastery with which the weight and the density of the spray are rendered. WINDSOR 12422

of what it must have been like, although worn out and discolored, is glimpsed in the zone above the window of the east side, where during restorations in 1954 a thorough cleaning was done. The restorers did not dare to remove completely all the reconstructions of Beltrami; they limited themselves to relieving the heaviness of the repaintings. But in the zone indicated they went so far as nearly to bring out the original. In that area the interstices of the

65

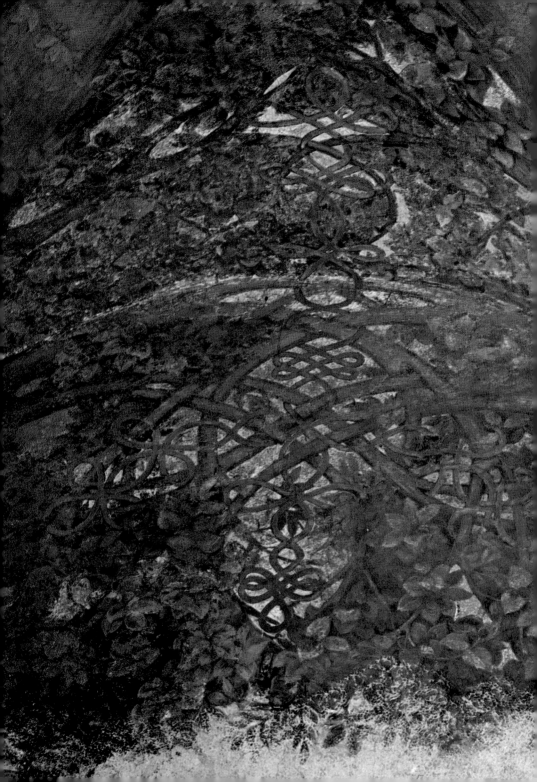

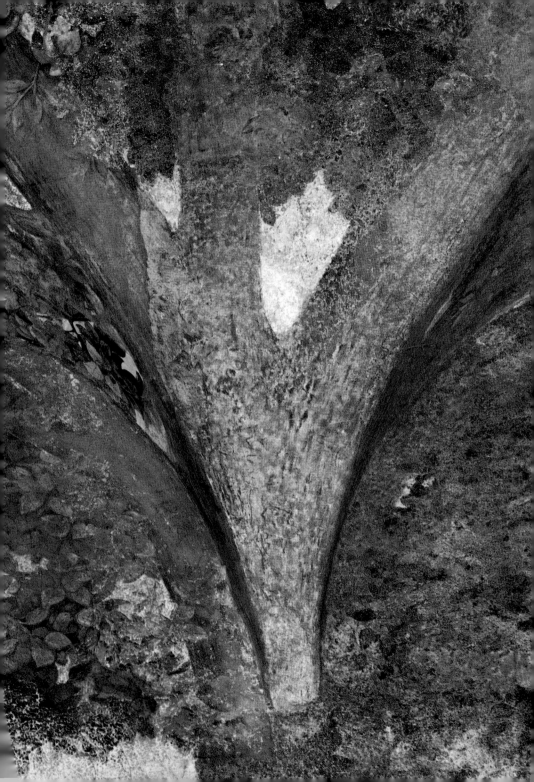

foliage leave a greater opening to the brightness of the sky; the leaves and branches are lighter and more wavy, studied in a much more naturalistic way, and rendered in their morphological details. The vegetal motif, although used for a decorative purpose, is animated by a charge of organic life and a naturalistic significance which is completely new.

The patron intended the work to be highly decorative; Leonardo lavished upon it the results of his studies on nature, which he pursued relentlessly in those years, and transformed into something of new, more complex implications even the traditional cultural motifs he received from the past.

The restorations of 1954 have also brought back to view a large monochrome fragment on the east wall of large roots that insinuate themselves between stratifications of rocks and swell up into a big, broad, solid base of a tree trunk, full of protuberances, from which the stem begins to grow. This fragment

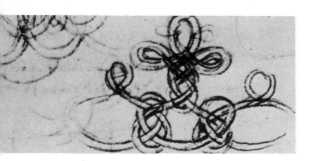

The knotwork pattern employed on such a monumental scale in the Sala delle Asse *corresponds rather well to the red-chalk drawing of interwoven ribbons here. Use of these interlacings in the complicated pattern of knots and loops in the decoration enhances the work of nature and reflects the intricacy of Leonardo's mind.*

WINDSOR 1235 v

leads one to suppose that initially Leonardo not only thought of decorating the vault but also imagined a single complex which would stretch across the whole hall, rising more organically from the earth. At the bottom, all around on the walls, as far as the impost of the vault, were to be big tree trunks, with their roots splitting and lifting the stratified rocks. Branches were meant to grow upwards and then bend to form an arbor, substituting for the enclosure of the stonework an arboreal construction in the open air. It was all conceived as the much more grandiose naturalistic poem that the surviving fragments show today.

Beltrami had covered over the big monochrome fragment, considering it as "work carried out during the Spanish domination"; it was rediscovered in the restorations of 1954 by Constantino Baroni, who judged it to be from Leonardo's own hand. I do not doubt that it belongs to Leonardo; and it amazes me

that a piece of this grandeur has so little aroused the attention of scholars. Joseph Gantner, after the presentation of Baroni, dedicated admiring and penetrating comments to it in his book on "Leonardo's visions,"[2] perhaps insisting even too much on its visionary character. The great contorted roots and the rising of the trunk swollen with protuberances do suggest strange forms; but I have never succeeded in seeing the human skull that Gantner discerns there.

Would they not be the famous spots on the walls of which Leonardo speaks and which stimulate the imagination to see there innumerable strange forms? The way in which the roots insinuate themselves between the joints and the stratifications of the rocks – upsetting them, breaking them, and making them rise – expresses a dynamic, almost animal vitality, bearing a stamp that is purely Leonardesque. When he carries out thoroughly the structural and representative analysis of the things in nature, Leonardo is eminently capable of extracting from it at the same time the maximum suggestion of compressed powers that may be enclosed there and are about to free themselves, overturning the difficult and precarious equilibrium of forces in tension. The result is an extraordinary metamorphic fantasy, a vision of the world – forces and forms – in perpetual action and transmutation left us by one with a formidable capacity for formulating them: "such a terrible demonstration," as Vasari called it.

Hundreds of drawings – survivors of who knows what mass dispersed and lost – illustrate Leonardo's vision of the world. I choose one in which this metamorphic vision materializes in a particularly striking way, a precise transition from a horse's head with fiercely upcurled nostrils to the heads of a roaring lion and of a screaming man, such a swift and yet securely interrelated transition as to suggest in the flashing rapidity of the image the whole sequence of the "photograms" implied. It is 12326 recto of Windsor, containing a series of sketches for the *Battle of Anghiari* (p. 80), which follows the works in the *Sala delle Asse* by roughly seven years. A mighty horse rears up to the right; another very small horse doubles up and launches into the fray like a meteor at the upper left; a whole series of beautiful horses' heads of a wild ferocity are scattered over the folio; and finally comes the unleashing of the threefold sequence of heads: horse, lion, screaming man – the three blending into one another from top to bottom, halfway up the folio. *Pazzia bestialissima* ("beastly madness"), Leonardo calls war, and this thought is here set down in a vision with lightning speed. How disengaged from the dull reality of the apparent fact this staunch representer of nature can be! From the image he arrives simultaneously at metaphor, mental discourse, and fantastic suggestion.

Upper part of the trunk, nearly a large arboreal console, which is immediately below the second corbel, from the northeast corner of the Sala delle Asse. All around the walls, placed below each corbel, are tree trunks with large branching boughs, rich with twigs and foliage, that simulate a

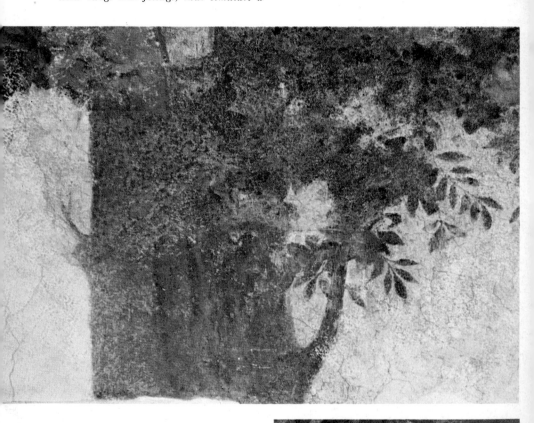

huge pergola in the open air on the entire ceiling of the Sala. Isolated from its context, this detail of a tree with its first short branches beginning to have leaves reveals the interest and care with which each morphological detail has been represented and the wonderful organic aliveness that has been infused into it by Leonardo. The detail at right shows clusters of leaves and fruit so vigorous and thick that they virtually obscure the branches.

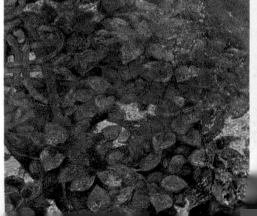

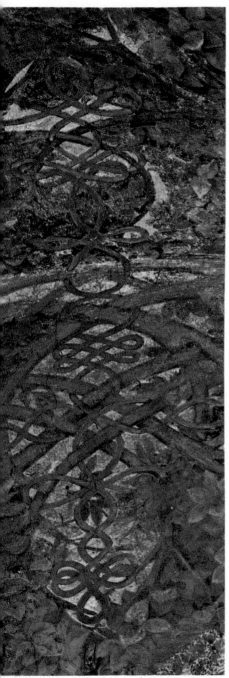

This detail of the first lunette and vault from the northeast corner of the **Sala delle Asse** *is from the area where recent restorations have achieved their finest result in removing the heavy repaintings. The intersections of the branches form complicated pointed arches like the tops of Gothic windows. Through the entire vault runs a single unbroken strand of rope, looped and interlaced, whose patterns resemble the intricate workings of Leonardo's mind.*

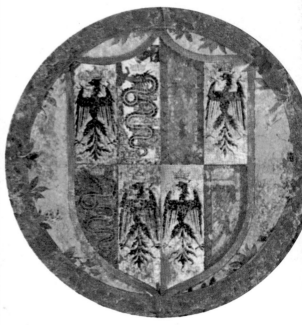

The coat of arms of the Sforza family, emblazoned with falcons and serpents, was painted at the very center of the decoration as a kind of keystone for the **Sala delle Asse.**

At left is the view looking straight up at the ceiling of the Sala delle Asse. *In the middle is the Sforza coat of arms, towards which rise the strong branches from tree trunks placed all around the hall. The ample and arbitrary repairs executed by Beltrami on the basis of scattered fragments of the original decoration do not allow us to judge whether the intersections of the tree trunks were indeed so close and regular: certainly they were not so monotonous and persistent. The foliage, besides the fact that it has been inserted in areas originally left blank, appears heavy and stiff because of the thick and dull repaintings.*

In 1954 restoration brought to light large fragments of Leonardo's work on the east wall of the Sala delle Asse. *In the detail of the fragment shown at right, roots can be seen insinuating their way through stratified rock and swelling into the base of a tree trunk. The roots, twisted and contorted like animals trying to free themselves from the rocks, have a dynamic quality typical of Leonardo's work. The fragment had been covered over by Beltrami who thought it the work of a later artist.*

The style of the *Cartoon of St. Anne* (p. 77) recently transferred to the Royal Academy at the National Gallery of London belongs to the period of the *Last Supper*. The presence of the great figures in the foreground, gravitating towards the real space from which the spectator looks at them, is once more felt. The painting shows the same plasticity in its fullness, and there are analogies of gestures, attitudes, and groupings. The *Last Supper* and the *Cartoon of St. Anne* were developed along the same lines of thought leading to an intense affirmation of naturalness, but on a monumental scale and involving a sum of ideas with universal significance.

A recent dating seeks to place the *Cartoon of St. Anne* two or three years after the *Battle of Anghiari*. Such a dating is unsustainable in my opinion, as it does not fit in with internal developments of Leonardo's art or even

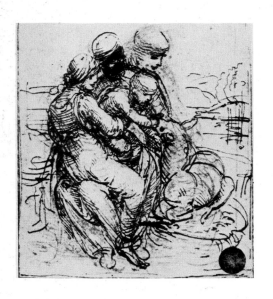

The famous painting of St. Anne, *now in the Louvre, was executed by Leonardo in a rather advanced period of his activity, around 1509–1510. For about a decade he had been meditating on this theme: he aimed at placing the four figures in a compact group, in which the reciprocal positions, gestures, and even looks would flow from one to the other, and from the top to the bottom by successive interlacings, torsions, and flexions, widening towards the base like a pyramid. This pyramidal scheme became an example for Italian painting of the first decades of the 16th century.*

At left is one of his preliminary sketches for the St. Anne.

– indeed, much less so – with the developments of that crucial decade in Italian art, 1500–1510. Too many Florentine drawings, as well as paintings and sculptures, in the first years of the 16th century re-echo that very new motif and make it the theme of variations and developments – not excluding Michelangelo, Raphael, and Andrea del Sarto. The style of the *St. Anne* does not deviate much from that of the *Last Supper;* it still belongs to that phase. The following phase is that of the *Battle of Anghiari*.

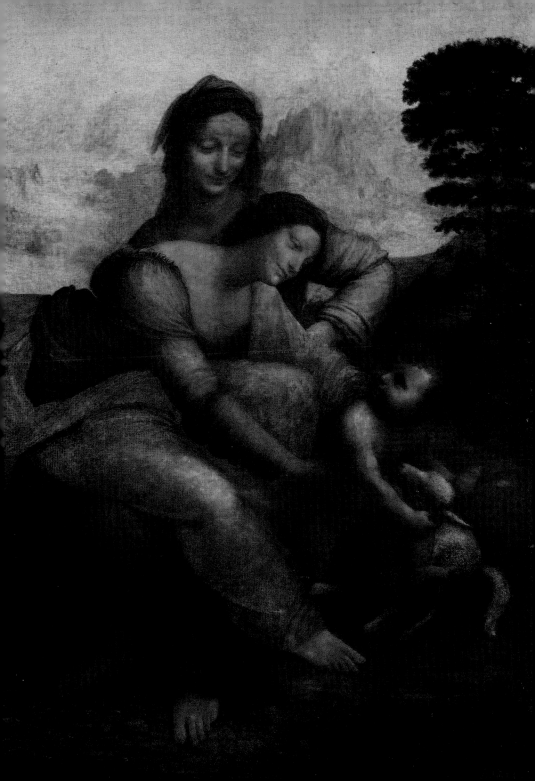

Due to the extraordinary structural and stylistic importance assumed by "pyramidal composition" in 16th-century Italian art, the comments about the various Vincian versions of the group of the St. Anne *tend to polarize on this particular aspect. But such an exegesis would be defrauding the* Cartoon for St. Anne *(now in the National Gallery in London), one of the greatest works of Leonardo, which belongs to the creative and stylistic phase of the* Last Supper. *It is true that the cartoon marks the beginning of a research series for the pyramidal composition, which ends with the painting in the Louvre; but in the long process many things have changed in Leonardo's thought, and the new realisations have not come about without discarding other elements. The version in London has the same emotional and psychological density, the same force and "naturalness" of execution as found in the* Last Supper. *The clash of the glance of St. Anne, coming from the shade, full of the awareness of the world, with the much more youthful and unaware face of the Virgin would have been impossible in the perfect pyramidal composition in the Louvre.*

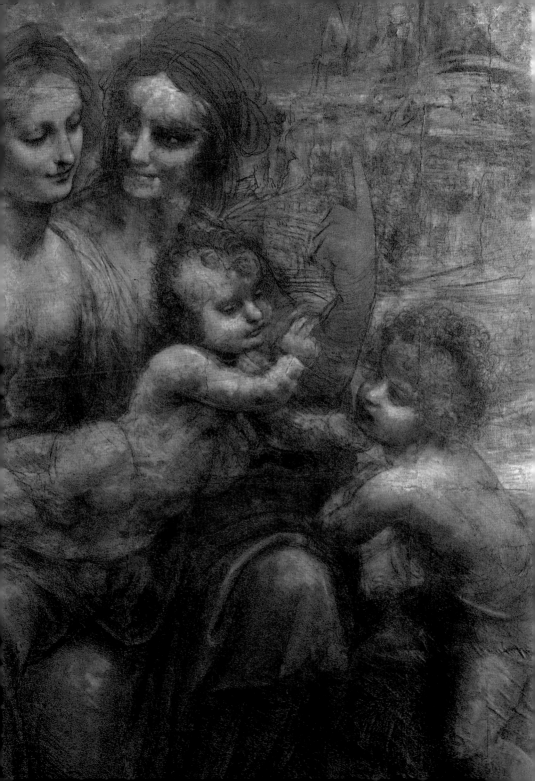

The Battle of Anghiari belongs to a totally different cycle of experiences and concepts. A new dynamism breaks into it with shattering vehemence. Here again the protagonist is man, but a savage ferocity is present. The figures whirl around in a vortex of motions, as if the forces dominant in nature were unleashing the elements in an attempt to absorb man himself. An abyss separates Leonardo's conception from the battles of Paolo Uccello, for example, of just 50 years before, in which every gesture and attitude is frozen in posture and every single part surrealistically composed and fixed within the network of the abstract and unchangeable relationships of specular perspective. With the *Battle of Anghiari* there is a violent break away from the perspective syntax of the 15th century; the group turns and rushes forward like a hurricane unleashed. Leonardo's mind becomes increasingly more removed from humanism and passes on to consider in an ever wider and more cosmic sense the forces, motions, and elements "of heaven and earth."

Up to now this essay on Leonardo's painting has followed the Madrid Codices chronologically, making reference, not to the manuscripts themselves, but to Leonardo's artistic work corresponding to the period which they span. This period runs from 1491 (which is the earliest date written on folio 157 verso of Codex Madrid II, in the notebook dealing with the casting of "the great

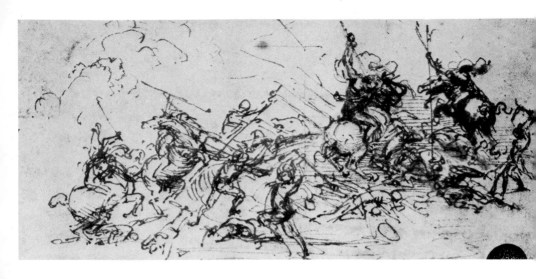

In the drawing above, a fight between
horsemen and foot soldiers is represented
with an overwhelming violence of line.
GALLERIA DELL'ACCADEMIA 215 A, VENICE

*This folio from the newly rediscovered
Codex Madrid II immediately became fam-
ous for the explicit mention of the* Battle of
Anghiari. *The passage referring to it is
written in the middle of the folio (and
transcribed above): "Friday the 6th of June,
1505, at the stroke of the 13th hour, I
started to paint in the Palace. And just as I
lowered the brush, the weather changed for
the worse and the bell started to toll, calling
the men to their duty. The cartoon was torn,
water poured down and the vessel of the
water that was carried broke. Suddenly the
weather became even worse and it rained*
very heavily till nightfall and the day was
as night." The note has been interpreted by
some as the solemn autobiographical men-
tion of the day when Leonardo started his
painting on the wall of the Hall of the
Great Council in the Palazzo Vecchio. I
believe however that, as in other cases,
Leonardo is fascinated by a meteorological
phenomenon, exceptional and spectacular,
and mentions the exact day, hour, and
moment: "At the moment I put the brush
down the weather deteriorated. . . ."*
MADRID II 1r

79

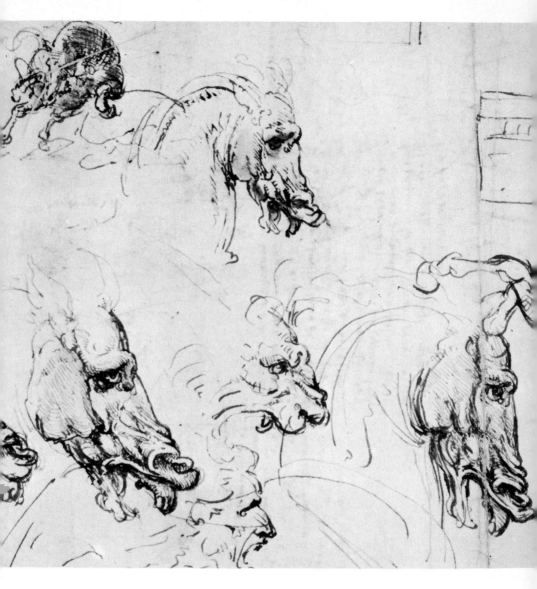

horse of Milan") to 1505 (on folio 2 recto of the same codex, where the record of the *Battle of Anghiari* is found). The other codex, Codex Madrid I, more unitary and homogeneous, contains the two extreme dates of 1493 and 1497.

At this point it is time that the essay concentrated on the Madrid Codices.

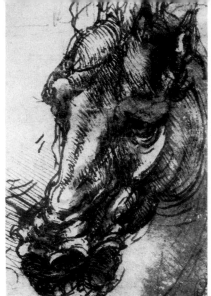

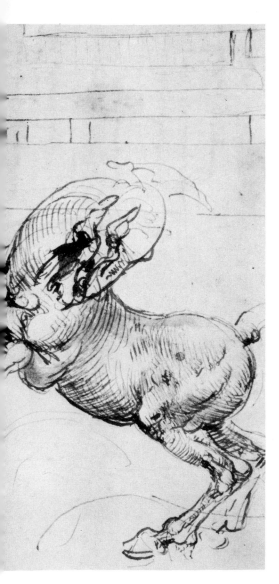

This ferocious horse is another of Leonardo's sketches for the Battle of Anghiari.

This folio must be related to "a book of horses sketched for the cartoon" of the Battle of Anghiari, *mentioned in the long list of books that spreads over folios 2 verso and 3 recto of Codex Madrid II. At the left, going from top to bottom, are drawn the head of a horse with its nostrils ferociously opened followed by the head of a roaring lion and then the head of a screaming man in a series of events so fast and connected that they give rise to the suggestion of a metamorphosis from one to the other image.* Pazzia bestialissima, "beastly madness," *Leonardo calls war, and this thought is here set down in a vision of lightning speed.*

The passage of folio 2 recto (p. 78) of Codex Madrid II which is illustrated and transcribed above became immediately famous for its reference to such a well-known work as the *Battle of Anghiari*. It has been published several times already, and differing opinions have arisen as to its precise meaning. By some the passage has been taken as a solemn – and superstitious – autobiographical record of the day on which Leonardo began the *Battle of Anghiari*,

81

recalling the first stroke of his brush on the wall of the Palazzo Vecchio in Florence. It has been underlined at some length how Leonardo emphasizes that June 6, 1505, fell on a Friday, a day considered by popular superstition to be unlucky, and notes the breaking out of a terrible storm, an event likewise popularly interpreted as an ill omen. But if Leonardo too was superstitious, why on earth would he have chosen precisely a Friday to begin "to paint in the Palace"? Unfortunately, these inauspicious premonitory signs seem to be confirmed *a posteriori* by the fact that the *Battle of Anghiari* was left unfinished following a series of accidents and contretemps. Nevertheless this interpretation does not seem to me to have solid bases, and I consider the meaning of the passage to be quite different. In its excited crescendo, it sounds like the record of an exceptional meteorological phenomenon ("Suddenly, the weather became even worse and it rained very heavily till nightfall and the day turned to night"); and the punctual reminders of the day ("Friday the 6th of June") and the time ("at the stroke of the 13th hour") and even of the action ("As I took up the brush") take on the meaning and the value of a conscientious chronological note and document of the extraordinary happening. However interesting the passage may be for its reference to the famous *Battle of Anghiari*, it is still nothing more than a note and a document, viewing Leonardo's artistic work from the outside.

The wonderful series of drawings that illustrate almost every page of the Madrid Codices constitutes in itself the subject and substance of a work of art. Indeed so great is the many-sided variety of aspects presented by this great mass

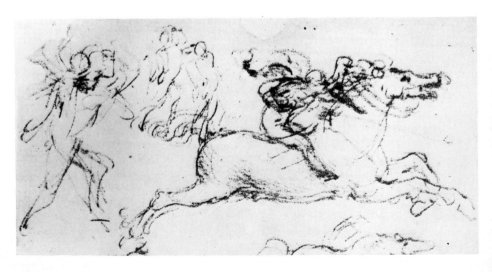

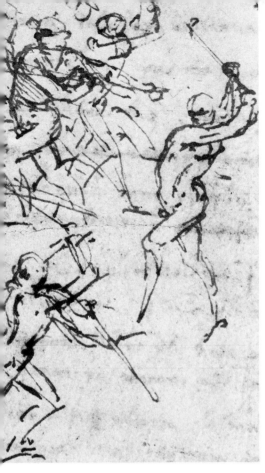

Figures of walking soldiers are studied in order to investigate fully the play of muscles in various movements and attitudes of attacking and striking. These serpentine movements became, like the pyramidal scheme of the St. Anne, a dominant means of composition in the following decades of the 16th century.

GALLERIA DELL'ACCADEMIA 215, VENICE

Another sketch for the **Battle of Anghiari** (below) pits nude warriors against horsemen.

GALLERIA DELL'ACCADEMIA 215 A, VENICE

The rough sketch below, opposite, shows a galloping horse and rider, his cloak flying out behind him in the fury of the run; to the left the outlines of foot soldiers.

WINDSOR 12340

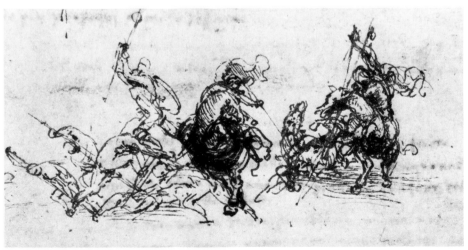

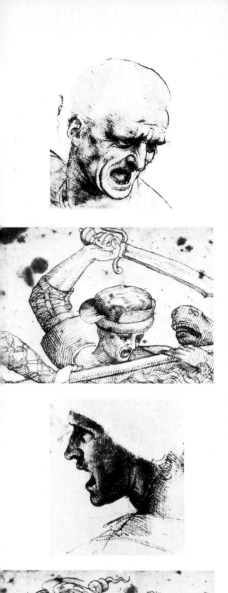

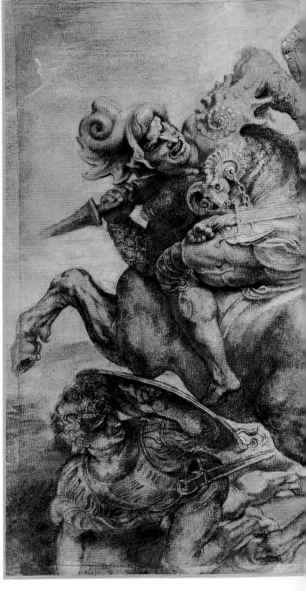

At left, two preliminary drawings by Leonardo for the Struggle around the Standard *in his* Battle of Anghiari, *and beneath each sketch, a detail showing the same subject as treated in the Rucellai copy, by another artist, of Leonardo's Anghiari.*

84

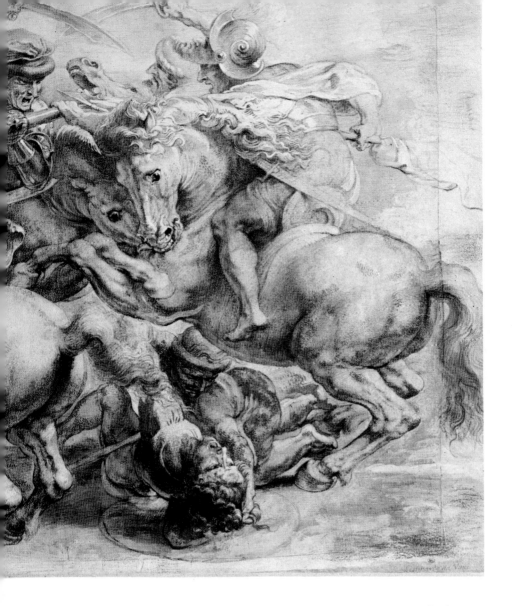

Peter Paul Rubens's copy of the Struggle around the Standard *from the* Battle of Anghiari, *Louvre, Paris, and the Rucellai copy from the Palazzo Rucellai in Florence, two details at left, are (among the numerous ones that have reached us) those that provide the most help in reconstructing the Vincian composition and the impression* that emanated from it. Even though the Rubens copy presents numerous variations to the Vincian painting, Rubens has, like no one else and with extraordinary power, caught its meaning, its violence, and its confused fury, interpreting it with incomparable immediacy and authority.

of drawings, so multiple the meanings and implications contained in it that even the definition "work of art" seems to be an understatement. In the centuries after Leonardo, cultural processes took place which brought about a specification of the concept of art. Art – and consequently drawing – became more and more emphatically stylistic and aesthetic, with the end result being discriminative and restrictive.

In Leonardo's day and in his hands, drawing still had a polyvalence, a high inventive and creative quality. Its rules were flexible and it possessed such a wealth of meaning and communicative force as to enable it to be truly associated with the word. This is language expressed through images, but more direct and more readily intelligible than the word itself, because "painting

For Leonardo, drawing was a kind of language, in images that were more immediate and telling than the word itself. Often, in his notebooks, he switched from the written word to sketches to make his point graphic or even as a means of debating with others or himself. He made the beautiful drawings on these two pages to demonstrate the impossibility of perpetual motion – a chimera that had intrigued many thinkers over the ages and a notion that Leonardo himself may have had interest in as a young man. In

pinwheel-like drawings on this page, from Codex Forster II, folios 90 recto, 91 verso Leonardo suggests with a stroke of the pen the energy of movement. The drawing on the opposite page is from Codex Madrid II, folio 145 recto, where Leonardo made repeated notes on gravity, trying to define that then elusive force. In Forster II he is scornful of the seekers after perpetual motion, likening them to the alchemists who tried to convert base metals into gold.

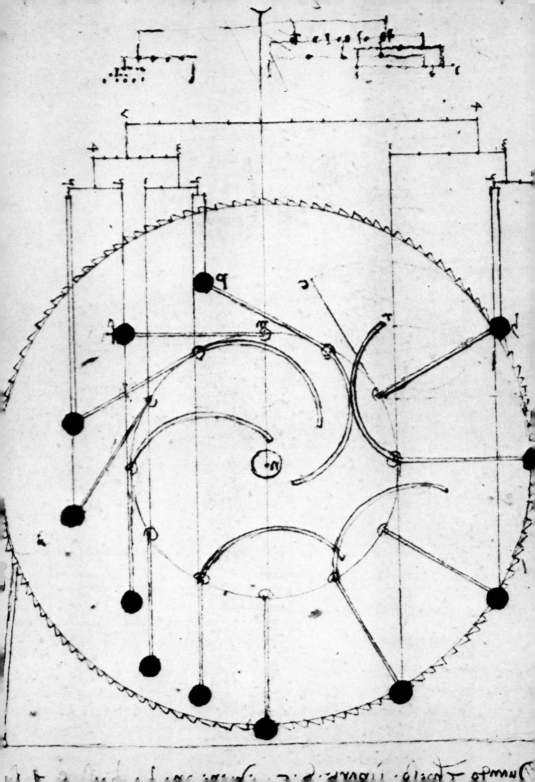

does not have need of interpreters for different languages as does literature," as Leonardo declares in the *Treatise on Painting* in the *Paragone,* where he compares the arts. Later in the *Paragone* he continues:

"By means of her basic principle, that is design, she [painting] teaches the architect to make his edifice so that it will be agreeable to the eye, and teaches the composers of variously shaped vases, as well as goldsmiths, weavers and embroiderers. She has discovered the characters by which different languages are expressed, has given numerals to the arithmetician, has taught us how to represent the figures of geometry; she teaches masters of perspective and astronomy, machinists and engineers."[3]

The very last words of this passage can stand as the most pertinent introduction to the wonderful series of drawings of machines, devices, and mechanisms (p. 93) which fill Codex Madrid I. Exquisitely clear, these become the instrument of research and analysis. Even as they are in progress, the drawings become a means of testing and checking the device which they are intended to represent; successive versions are tried out, and improvements are proposed and discussed through the illustrations: a true mental discourse, a creative process which, evolving and developing, finds in the drawing its clarifying and communicating instrument. Leonardo's drawing of machines is so straightforward and demonstrative that it even succeeds in charging the representation with a dynamic suggestion which makes clear not only their structure but also their function.

In the sketches where the idea is more rapidly committed to paper, this power of suggestion is conveyed especially by the unfinished, barely outlined aspect of the diagram, by the fleeting character of the tracing, and by its interruptions, which serve to illuminate improvements of the modeling of the form; or by the deep impressions in pen-point. The most typical examples of this rough and hasty type of sketch in the Madrid Codices are found in Codex Madrid II, which is much less homogeneous than Codex I and whose prevalent character is that of a notebook. On folio 76 recto, for example, on musical instruments, the tracing is thrown in various directions, sometimes making such a deep impression as to finish in pen-point, sometimes light and swift, seeming to suggest not only the form of the musical instruments but even the bursting forth from these of the sound and the musical notes.

Another example in the same manuscript is found on the pages he dedicated to the flight of birds[4] (see page 90). In the margin beside the text they contain

a row, running from top to bottom, of figures of birds drawn synthetically: a few strokes for the spindle-shaped body, a few strokes for the open wings in a succession of various positions and motions of flight. The progressive simplification of the form succeeds in the last figure in representing the tapered body of the bird, in a foreshortened frontal view, like a circle, and the wings in the form of two articulated arms which make it move – a wonderfully illustrated conclusion in synthesis of the mental process by which Leonardo interpreted the flight of birds in terms of elementary mechanics.

In the other codex, Codex Madrid I, which on account of its homogeneousness and coherent succession of arguments could be called a book of the elements of machines, even the drawing has a more analytic and finite character. The various machines and their "elements" are described with precision and objective evidence of details, in their form and structure. But here too Leonardo finds a way of getting across most effectively the image of their motion and function by other means. He makes his drawing technique conform to the different processes of his "mental discourse." It is enough for him to mark with a light stroke around the pivot – the "pole" as he calls it – a circle over the regular shadings which give body to the drawing of the machine, so that this circle, all the more immaterial because of the lightness of the stroke, suggests the rotating motion which takes place around the pivot.[5]

On other occasions, the diagrams of motions are freed from any reference to a given device and are studied abstractly for their own sakes, and their courses are noted and related to variations of force and weight. The concepts are illustrated according to the direction of the motions, with intersections and points of reference. Sometimes very complicated abstract compositions of great harmonic beauty result from this, as on folio 148 recto; sometimes we see instead an open succession, as it were, of single diagrams placed in a row one behind the other like numbers in an addition; but even in this case the tracing is so evident and pertinent to the concept as to constitute its most direct and effective demonstration. In such cases the drawing becomes the equivalent of the word, equally capable of conveying abstract mental processes. On folio number 131 verso, on one side the text lists a whole series of "simple" motions, and opposite this a series of diagrams alive in its sequence of lines, circles, zig-zags, and spirals visualizes and makes immediately evident – and dynamic – the definitions of the written words. And while we are on the subject of these two pages, it ought to be pointed out what a magnificent page-setter Leonardo can be when, instead of amassing his notes in such a

When Leonardo drew birds, his extraordinary quickness of eye enabled him to freeze their motions in flight with the sureness of a high-speed camera. Leonardo analyzed their positions in flight and dissected specimens. These drawings demonstrate this progression from art to the abstractions of science. In this manner he has gone from depicting the flight of birds to depicting the mechanics of flight.

Opposite:
"If one wants to see the separated rays, the mirror must be given the shape of a half ring, which is flat inside; then one makes a mixture watered down with egg and one covers with the brush once or twice, and when it is dry one takes it away with a wooden stiletto without scratching the mirror, and so we will see the separated rays on the plan a b c as their causes are separated."

CODEX ARUNDEL 87v

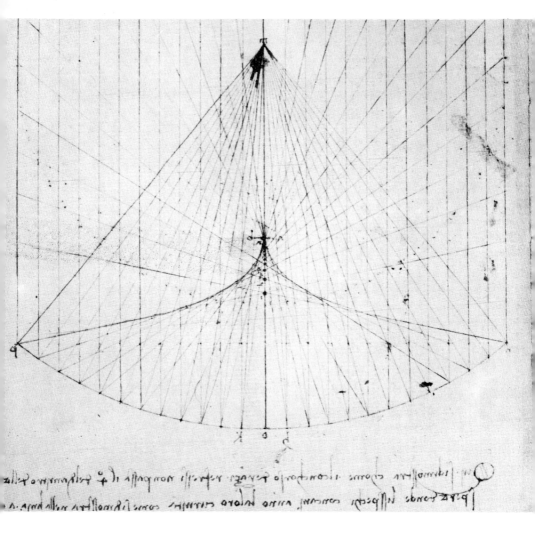

disorderly fashion that they often overlap one another, he takes pride in setting his page as in these last two folios.

In the drawings of machines in Codex Madrid I we can also trace the formation of a method of drawing which, side by side with the evolving method of architectural drawing, tries to perfect representation in plan and in elevation. A typical example is folio 44 verso. And in elevation, it is interesting how Leonardo seeks to obtain a variety of views – front, side – as if aiming at presenting successive orthogonal projections without optical deformation.[6]

Architectural design and, as it is known today, industrial design reveal even in the Renaissance a researching of analogous methods of representation, and Leonardo participates directly in this process in both fields. His own words reveal how aware he was of the creative quality of drawing in it: "Drawing is of such excellence that it not only searches the works of nature, but infinitely more than what nature does."[7]

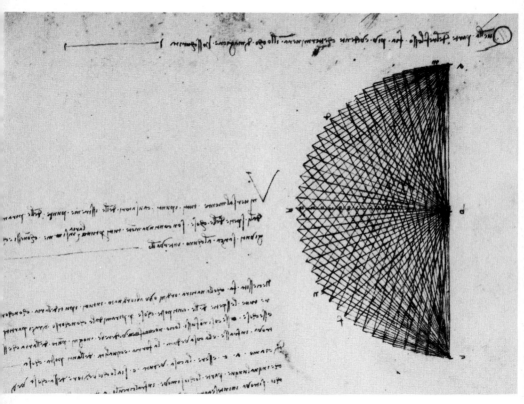

Another study of the reflection of rays: the incidental ray is reflected (in the drawing by the line a b c) with angles that are further away from a right angle the more obliquely the incidental ray hits the surface. From it derive countless pyramids which spread in all directions. This precisely calculated and geometrically perfect web of numerous pyramids is interwoven marvelously in the semicircular space of this drawing. MS. A 20r

This drawing of a textile machine – in plan and in elevation – is presented here only to indicate how Leonardo searches for and uses in the drawings for machines analogous methods to those he searches for and arrives at for the architectural drawings. MADRID I 44v

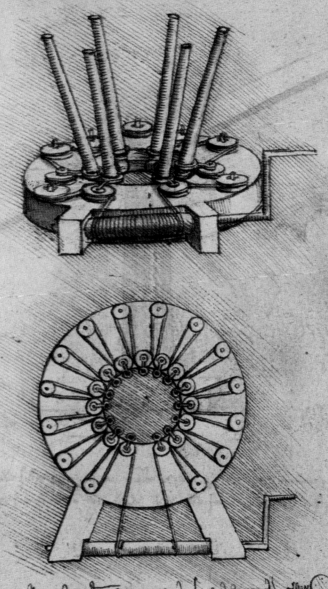

The discussion has dwelt upon these particular aspects of Leonardo's drawing because the very characteristics of the greater part of the drawings that illustrate the Madrid Codices required that it be so. The discussion would seem to risk being incomplete, however, were it to pass over the other more generally known and more properly artistic aspects: the drawing of figures and landscapes. As usual, Leonardo interpreted and rendered these in a way which was very original in comparison with the tradition of the Florentine school and which showed that he was ahead of his time.

In the Madrid manuscripts drawings of human figures are hardly present but there are magnificent examples of landscape drawings (see below) on folios 7 verso, 4 recto, and 17 recto of Codex Madrid II: crests of mountain chains, light, aerial, yet so individualized in their depressions and profiles as to be immediately recognizable even though unmarked by little names. For example the mountains of Monte Pisano. To draw them, Leonardo used red chalk, supple so as to make it possible to avoid every harshness of profiling, crumbling softly on the sheet to render the luminous richness of the whirling air. Here he indeed "searches the works of nature," and one cannot but recall, while admiring the aerial beauty of the drawings, the intelligence and openness of the phrase. He did not write "imitates," but "searches." His phrase welds these landscape drawings, although intended to express quite different interests and sensibilities, to the spirit of research, of contemplation, and of investigation, and to the extraordinary open-mindedness and organicity that characterize everything Leonardo did.

The painter contends with and rivals nature.
FORSTER III 44v

You will observe in your painting
that shadows among shadows
are imperceptible in density and outline...
Things seen
between light and shadow will display much more relief
than those seen in light or in shadow.
MS. E 17r

Of all studies of natural causes,
light gives greatest joy to those who consider it;
among the glories of mathematics the certainty of its
proofs most elevates the investigator's mind.
Perspective, which shows how linear rays differ according
to demonstrable conditions,
should therefore be placed first among all the sciences
and disciplines of man,
for it crowns not mathematics
so much as the natural sciences...
ATLANTICUS 203r-a

If you disparage painting,
which alone imitates all the visible works of nature,
you disparage a most subtle science which by philosophical
reasoning examines all kinds of forms:
on land and in the air, plants, animals, grass, and flowers,
which are all bathed in shadow and light.
Doubtless this science
is the true daughter of nature...
MS. A 100r

"Again, the bronze horse may be taken in hand,
which is to be the immortal glory
and eternal honor of the prince your father...
and of the illustrious house of Sforza."

THE
SCULPTOR

MARIA VITTORIA BRUGNOLI

Il Cavallo – "The Horse" – was a colossal equestrian statue commissioned by the Duke of Milan, Lodovico Sforza, in honor of his father, Francesco (above). The monument was to be the largest such sculpture ever built – Leonardo designed the horse alone to be more than 23 feet high – and would require the development of a radical new casting method.

'In the evening, May 17, 1491. Here a record shall be kept of everything related to the bronze horse presently under execution." These words, from Codex Madrid II, folio 157 verso, are the starting point of Leonardo's notes on a project which could well symbolize both the times – the tumultuous changes of Renaissance Italy – and the man – artist, scientist, innovator.

The "bronze horse" was to be a monument to Francesco Sforza, father of Lodovico il Moro, who was Leonardo's patron in Milan for many years. *Il Cavallo* – "The Horse" – was actually to be a horse and rider as envisioned by Galeazzo Maria Sforza, Francesco's older son who commissioned the creation of a life-size equestrian monument. However, when Lodovico succeeded Galeazzo Maria and established his court as one of Italy's most glittering, the plans for *Il Cavallo* developed to a statue that would measure over 23 feet high, weighing some 158,000 pounds. Lodovico's political maneuvering was unfortunately not adept enough to establish a permanent reign, and his political difficulties were reflected in the monument's erratic progress during the 16 years that Leonardo worked on it. The ultimate fall of the house of Sforza was parallel to the fate of *Il Cavallo,* which was never

realized in bronze. Folios 141 to 157 of Codex Madrid II, the record of Leonardo's work on the enormous bronze monument, are thus a unique source commenting on the passage of a grandiose Renaissance concept through the political upheaval so much a part of that time.

This series of folios is important not only for its political and historical contributions but also for what it reveals about Leonardo. The sketches here confirm what is known from the rest of Codex Madrid II and the other notebooks about the beauty of Leonardo's drawings, his perfectionist attempts to understand fully the musculature and bone structure of a living subject, his attention to the most minute detail of a mechanical device. The writings confirm the image of Leonardo as scientist: experimenting with different combinations of materials for molds, advising in instance after instance that his assistants try out all kinds of different materials to see which would best suit the purposes and circumstances of a

The originator of the horse project was Lodovico's brother and predecessor as duke, Galeazzo Maria. He had in mind a life-size monument to his father, and he commissioned a search all over Italy for a "master capable of realizing it." After he was murdered in 1476, his young son Gian Galeazzo became the rightful heir to the duchy, but the boy's uncle, Lodovico, kept him out of the way and later probably was responsible for his being killed with poison.

The king of the French troops who took Milan and threw out Lodovico Sforza was Louis XII (at far right). His commander at Milan was himself a Milanese – Marshal Gian Giacomo Trivulzio, a noted condottiere, or mercenary leader. Later he asked Leonardo to create an equestrian statue.

particular problem, considering and weighing everything relevant to the problem, and explaining in precise scientific detail his reasoning and methodology for every step.

Leonardo the innovator – this is perhaps the greatest significance of the Codex Madrid II folios on *Il Cavallo*. The problem that Il Moro presented to Leonardo, to cast a bronze horse four times greater than life size, could not be solved to the satisfaction of a perfectionist like Leonardo with the then existing methods of

casting bronze. In this codex he clearly outlines a new method of casting bronze in a single operation. Once again Leonardo the innovator proved himself to be years ahead of his contemporaries: in fact we find the first reference to his new method of casting in the treatise on "Pyrotechny" written between 1530 and 1535 by Vannoccio Biringucci, an expert cannon founder. Giorgio Vasari and Benvenuto Cellini give a detailed description of it around the mid-16th century, but they recommend its use only for life-size or slightly larger figures. Only two centuries after this new method was developed by Leonardo was it to be used for a large-size monument like the one planned for Francesco Sforza: the equestrian statue of Louis XIV of France, the Sun King.[1]

To read and understand the Codex Madrid II story of *Il Cavallo* gives one a better knowledge of Leonardo and also provides a fascinating parallel to the political history of the Italian Renaissance. For the story revealed in Leonardo's notes is

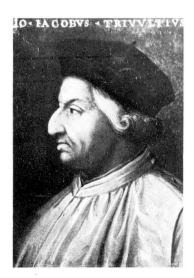

also that of the Sforza family, who serve as a symbol of their time. The Sforzas rose to power in Milan in a style that could perhaps typify the political mood of 15th-century Italy. Francesco Sforza (p. 97) was *a condottiere*, a free-lance general hired by Milan to fight against Venice. Claiming that his wife was the illegitimate daughter of the previous Duke of Milan, Francesco took Milan for himself. His son Galeazzo Maria (p. 98), who came to power at Francesco's death, suggested that a monument be built to his father's memory. This monument was to be life-size and "placed in the open somewhere in our castle of Milan." In November

1473 he instructed Bartolomeo Gadio, an architect, to seek out a "master capable of realizing" the monument. Gadio was authorized to search beyond Milan – to inquire anywhere that "this master so excellent as to be able to carry out his work was to be found."²

Three years later, in 1476, Galeazzo Maria was murdered, and his son Gian Galeazzo inherited the dukedom. At this point Lodovico, Galeazzo Maria's brother, took the throne away from his nephew; he claimed that his status as Francesco's younger son was a more direct link to the dukedom than Gian Galeazzo's. Lodovico revived the idea of the monument and renewed the search for a master.

Leonardo's patron, Lodovico Sforza, was known as Il Moro – the black – probably because of his swarthy complexion. He is shown here in a detail from the Sforza Altarpiece, which represents Lodovico being introduced to the Virgin and Child.

Opposite page: The downfall of Lodovico Sforza – and the horse – became imminent late in 1499 when the French invaded Milan. Il Moro fought on for a few months but he was defeated in a battle at Novara and led off to a French prison. This illustration from an old Swiss chronicle – the Diebold Schilling chronicle, kept in Lucerne – shows Sforza, disguised as a Swiss civilian, being arrested by one of his Swiss mercenaries who had betrayed him.

Leonardo, in Florence, must have been following the changing events in Milan with some interest. In 1482 he wrote to Lodovico introducing himself to the Sforza court in a manner that suggests he was somehow selecting the winner in the struggle for Milan. He offered designs for bridges to be used in sieges, mortars and big guns, covered chariots, catapults; architectural designs for public and private buildings for times of peace; and, at the end of the letter, referred to the "bronze horse" – "to the immortal glory and eternal honor of the prince your father of happy memory, and of the illustrious house of Sforza."³

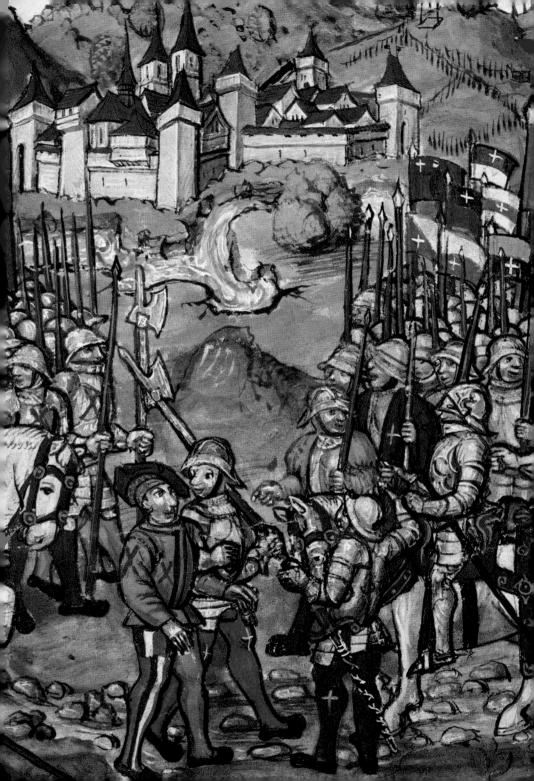

The court of Il Moro to which Leonardo came was one of the most brilliant in Europe. Lodovico lived in a grand manner – filling the court with poets, beautiful women, musicians, dwarfs, astrologers, and, of course, Leonardo.

He came to the court prepared to work on the bronze monument to Francesco, and there are some drawings from this period of a rearing horse.[4] (p.104) He was already posing for himself the problem of casting a bronze model of such a horse.[5] Although Lodovico aroused great public enthusiasm for the horse, work progressed gradually during the artist's stay in Milan, since Leonardo was also occupied with painting the *Last Supper* and other works such as portraits and was involved in a variety of civic and military improvements: he designed a new city plan and safe sewage system after the plague killed thousands in the 1480s; he also designed dozens of new weapons and an improved defense system for the castle. But Lodovico ignored these designs and preferred to employ Leonardo on such projects as managing opulent wedding festivities, or composing rhymes and puzzles for the ladies of the court. Not only did Il Moro utilize Leonardo's talents on trivial matters while ignoring the more serious ones, he was sometimes also stingy with Leonardo, who once wrote to Il Moro complaining: "It vexes me greatly that having to earn my living has forced me to interrupt my work and to attend to small matters, instead of following up the work which your Lordship entrusted to me . . . if your Lordship thought I had money, your Lordship was deceived."

For the 16 years that Leonardo remained at the Sforza court, *Il Cavallo* was the project that united him with Lodovico, but even here the encouragement was uneven. When Leonardo's work was still at a preparatory stage, Lodovico decided to impose far more spectacular proportions on the monument, probably to symbolize his own increased political power. Leonardo's early studies had been of a rearing horse which would be feasible, although difficult, to execute life-size in bronze. A sketch in Codex Atlanticus folio 148 recto-a of a high and ornate base (p.118) confirms that this statue would have been life-size and placed, probably, in front of the main entrance of the castle.[6] However, Lodovico's changed demand for a horse and rider four times larger than life-size presented enormous technical problems. Leonardo may have felt dubious about such a large-scale project, and it is evident that Il Moro questioned Leonardo's ability to complete the project. On July 20, 1489, a letter was sent to Lorenzo de' Medici in Florence from Il Moro. (This letter was the first document relating to the Sforza monument that describes it as enormous.)[7] Il Moro asked Lorenzo for the names of one or two masters capable of realizing "a worthy funeral monument to my father . . . that is a very big bronze horse carrying the Duke Francesco in armor." Although the mold of the

During the Renaissance the horse was considered second in nobility only to man. In his great unfinished painting the Adoration of the Magi, *done before he went to Milan, Leonardo created a rearing* horse *(detail below) that embodied his dynamic vision of nature. He returned to this horse in his early studies for the Sforza monument and later for the* Battle of Anghiari.

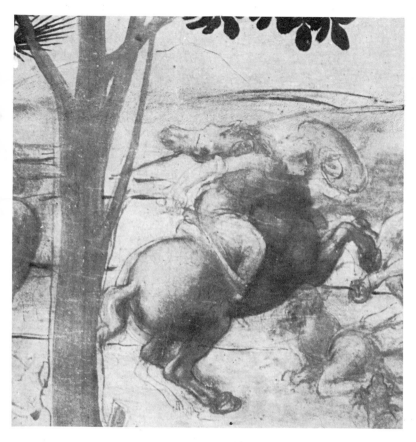

monument had already been commissioned from Leonardo, this letter reveals Lodovico's lack of confidence in his ability to finish. It was difficult, however, for Lorenzo to find a master on the level of Leonardo, particularly since Verrocchio, Leonardo's teacher, had since died. Thus on April 23, 1490, Leonardo wrote, "I resumed work on the horse."[8] In the drawings of the early 1490s, including those of Codex Madrid II, the equestrian monument shifts from a rearing to a pacing horse, the first sign that Leonardo was now working seriously on the tremendous monument. And it was approximately a year later, in May 1491, that Leonardo began the record in Codex Madrid II, that was lost for so many years,

from which the modern reader gains his knowledge not only of the completely innovative techniques derived for casting and molding the Sforza horse but also of the design and final model of the monument.

A rearing horse of such magnitude presented great problems. The other option with which Leonardo must have been familiar was a pacing horse cast in a frozen position with both fore and hind legs on the same side moving simultaneously, as seen in Verrocchio's Colleoni monument in Venice (p. 108), as well as the equestrian statues of San Marco in Venice (p. 109) and the Gattamelata of Donatello in Padua (p. 108). Although practical to cast and more stable than the rearing horse of Leonardo's drawings, the horses of those monuments have an unnatural and restrained appearance to a keen observer such as Leonardo.

Leonardo's problem was thus to find a way of rendering the pacing horse more realistically. His drawings from the Windsor Collection include a sketch of the

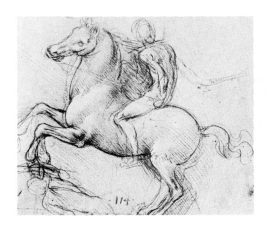

In his early studies for the Sforza monument Leonardo repeated the motif of a rearing horse that he had painted so successfully in the Adoration.

After 1489, when Sforza apparently decided to increase vastly the size of the monument, Leonardo changes its positioning. In the sketch (right) he draws a more conventional walking gait with the bent right foreleg raised. WINDSOR 12346

In 1492 Leonardo was laying plans for casting the new enlarged horse. This sketch portrays a walking horse mold enclosed by three braces. WINDSOR 12350r

Regisole monument of Pavia (p. 109) and in Codex Atlanticus we find a description which shows his regard for the successful resolution of the problem in that monument: "What is admired above all else in the Pavia horse is the movement.... The trot is almost of the same quality as the trot of a free horse."[9] Interestingly, Petrarch's description of the Regisole monument – "the statue of a horse almost running to the top of a hill"[10] – is very similar to the description of the model of the Sforza horse – "impetuous and panting in appearance" – which was made by Paolo Giovio.[11] It is thus most likely that the Regisole exerted a greater influence than any other monument on Leonardo's choice of design and model for the Sforza monument.

It is probable that Leonardo devoted a greater proportion of his time, especially at these early stages, to the study of horses than to the study of monuments. Again, the Windsor notes contain his sketches and observations made in Il Moro's stables, where he drew the horses repeatedly, measuring their proportions, the bone and muscle structure, the movement of their limbs[12] (pp. 114–115). Although Codex Madrid II contains primarily diagrams and sketches that explain the technical notes, there are also beautiful freehand drawings, as on folios 147 recto and 151 verso (p. 115, right) of December 20, 1493. These drawings represent the model at a more advanced stage and show a horse in a brisk pacing rhythm between the walk and the trot, with left hind leg raised from the ground and right foreleg bent at almost a 90-degree angle.[13] This is a very slight exaggeration of the natural pace and is somewhat like the parade step of the classical monument to Marcus Aurelius.

It is difficult to say, however, which of the two drawings mentioned above

represents the final choice adapted by Leonardo for his model. The hasty black-pencil drawing of folio 147 recto appears more spirited and seems better fitted to Paolo Giovio's description of the actual model. The red-chalk drawing of folio 151 verso is, however, more contained and perhaps more elegant. It is quite similar to the "caged" drawing on folio 216 verso-a of the Codex Atlanticus (p. 122), which uses the motif of an overturned pitcher to prop the flexed foreleg.[14] There is no further trace of this motif in the drawings of Codex Madrid II, and it is probable that Leonardo discarded it because it made the horse's pace appear less natural. Unfortunately, the drawings cannot demonstrate conclusively the exact posture and movement of the horse in the final position. Even after the substantial

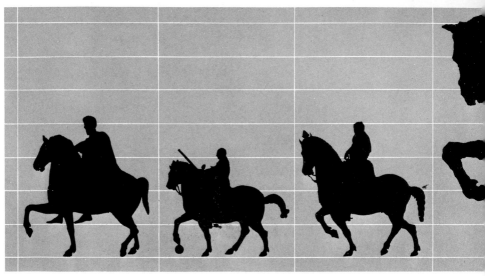

Marcus Aurelius
Roman emperor and philosopher; Rome; dated from antiquity; horse and rider 4.24 meters (14 feet) high.

Gattamelata
Famed mercenary general; Padua; 1453; horse and rider 3.20 meters (10½ feet) high.

Colleoni
Famed mercenary general; Venice; 1488; horse and rider 4 meters (13 feet) high.

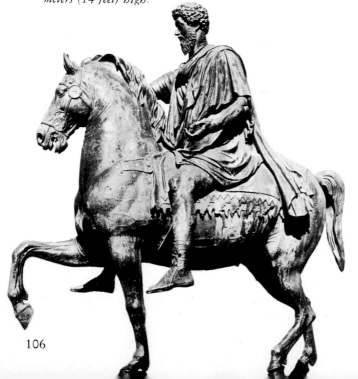

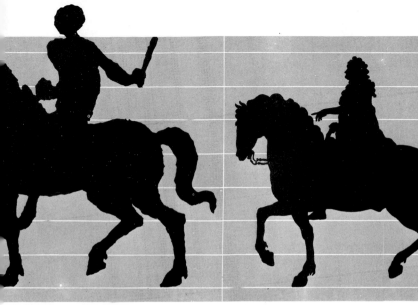

Sforza
Duke of Milan; Milan;
never cast; horse (only)
7.20 meters (24 feet)
high.

Louis XIV
King of France; Paris;
1699 (destroyed in
French Revolution);
horse and rider
6.82 meters (22⅔ feet)
high.

The chart above – comparing the metric height of the Sforza horse with that of four equestrian statues – illustrates the challenge facing Leonardo after his patron ordered a horse four times larger than life-size.

The Marcus Aurelius in Rome (far left) is very much like the Regisole that Leonardo saw in Pavia.

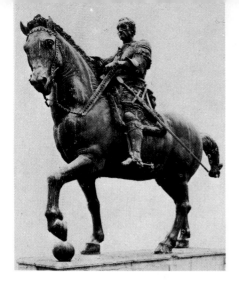

Donatello's monument in Padua to Con-
dottiere Gattamelata (above) probably
influenced some of Leonardo's sketches,
though he had only secondhand knowledge
of it.

The monument to the Condottiere Barto-
lommeo Colleoni in Venice (below) was the
work of Leonardo's old teacher Andrea del
Verrocchio.

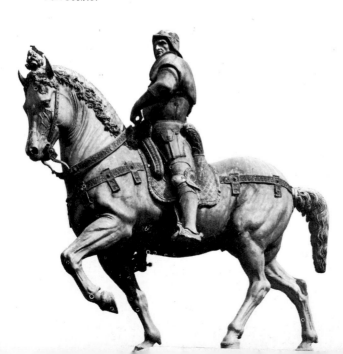

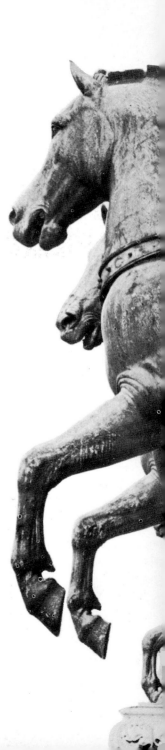

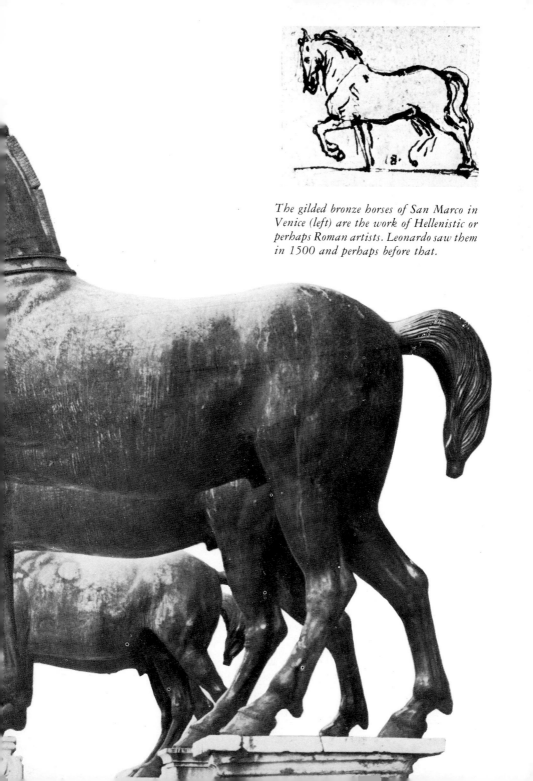

The gilded bronze horses of San Marco in
Venice (left) are the work of Hellenistic or
perhaps Roman artists. Leonardo saw them
in 1500 and perhaps before that.

contribution Codex Madrid II makes to knowledge of the Sforza monument, this question remains unanswerable.

There is also some confusion concerning the design for the base of the statue. Earlier monuments, such as those to Gattamelata or Colleoni, had marble bases, to which they were anchored by means of the pivot of the plinth. On folios 147 recto and 146 verso Leonardo introduces the problem of casting the base in bronze, and Codex Madrid II does not offer any answers as to why he posed this additional problem for himself. It is possible that he wished to avoid the imperfections of sutures between bronze plinths and marble. A reasonable answer could be found if the base of the monument had been planned in a limited elevation, as this would leave more or less within eye level the surface upon which the horse was to rest, thus revealing the unavoidable imperfections of the sutures between the bronze plinths and the marble. The hypothesis advanced here is not so farfetched if it is considered that a base projecting vertically like those of the Gattamelata and Colleoni monuments, if related in scale to the proportions of the Sforza monu-

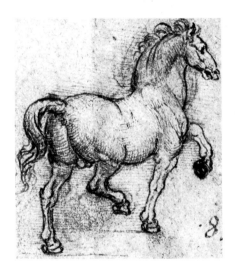

The accuracy with which Leonardo rendered horses and the play of their muscles indicates he probably dissected them. Contemporaries referred to his book on the anatomy of horses, which apparently was lost. The drawings shown here from the Windsor Collection both date from the time of work on the equestrian monument commissioned by Marshal Gian Giacomo Trivulzio about 1508 in Milan. Trivulzio, who led the French invasion of Milan in 1499, had hoped to become governor of the city, but his chances were wrecked by intrigue.

ment, would have reached such abnormal dimensions as to be very difficult to insert into the environmental and urbanistic spaces of the time.

Similarly, Codex Madrid II does not reveal any clear answer regarding the actual placement of the monument. Galeazzo Maria's original idea had been for a monument placed in the open outside of the palace. Old Milanese chronicles suggest the possibility of placing the monument near Francesco's burial mound;[15]

a 1491 manuscript of Bartolomeo Gambagnola containing a miniature with an equestrian statue very similar to the sketches of *Il Cavallo* suggests the placement of the statue in the vestibule of a temple.[16] It is likely that Leonardo favored neither of these alternatives and preferred a large open courtyard, but the codex offers no further clues on this problem.

The Codex Madrid II section on *Il Cavallo* is almost entirely concerned with the problems of casting and molding the enormous bronze statue of the horse and

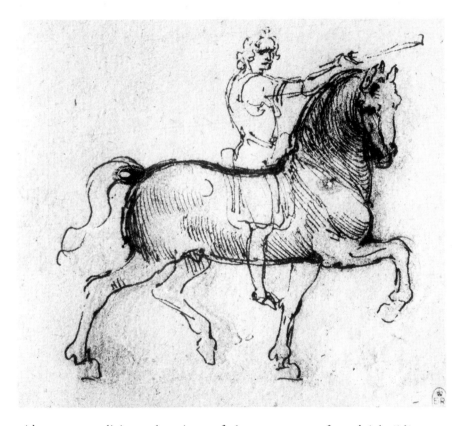

provides very explicit explanations of the processes of model building, preparation of the molds, casting the countermodel, preparing the casting pits and ovens, and finally casting the actual statue. Leonardo's system was revolutionary in terms of pre-existing techniques, and a close review of the material revealed in Codex Madrid II demonstrates the advantages of this system while also providing another context in which Leonardo's brilliance of conception and thoroughness of attention to detail can be seen.

Leonardo had resumed work on the monument in April 1490, and by May 1491 he had completed an earthen model for the great horse, as he writes in Codex Madrid II[17] concerning the relationship between the mold and the initial model of "the earthen horse." This mention in the codex is the first direct confirmation by Leonardo of the descriptions written by his contemporaries. Luca Pacioli confirms the enormity of the horse: it was 12 braccia, or over 23 feet high.[18] Others mention the substance of the horse. Paolo Cortese mentions a "clayey horse," Paolo Giovio a colossus in "clay," and Matteo Bandello an "earthen horse."[19] The codex does not clarify precisely what earthy substance the model was composed of. The Codex Atlanticus[20] does mention a "molding stucco" in an entry datable to about 1490, which may be the same mixture used for this model of *Il Cavallo*. This earthen model was unveiled in the old yard of the ducal residence in November

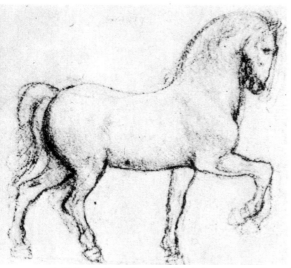

In both his attempts to make equestrian monuments Leonardo, characteristically, kept on searching for a practical posture to cast and yet that did not compromise the free and spontaneous qualities of real horses. The sketch at left, Windsor 12359, is another of his many studies for the Trivulzio monument.

1493, as the climax of celebrations of the betrothal of Bianca Maria Sforza to the Holy Roman Emperor Maximilian. It is not difficult to imagine the multiple prestigious effects of so prominent a marriage and so enormous a monument.

Even the mention of this earthen model reveals important information concerning Leonardo's decisions about the final casting. To make an earthen or stucco model meant rejection of the "lost-wax" process that was the universally used method of casting sculpture in the Renaissance. This process, of ancient tradition, was used in the classical age, and is clearly described in the *Schedula* of the monk Theophilus.[21] To cast a statue using the lost-wax method, models of the projected work are fashioned in wax over a core of refractory clay; an outer mold is then applied over

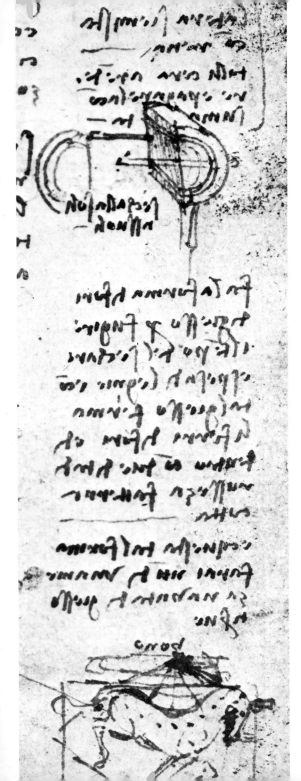

The clay should be mixed
with sand.
Take wax, to return
and to pay for what
is used.

Dry it in
layers.

Make the outside mold
of plaster, to save
time in drying and
the expense in wood; and
with this plaster enclose
the irons both outside
and inside to a thickness
of two fingers; make
terracotta.

And this mold
can be made in one day; half
a boatload of plaster
will serve you.

The accompanying transcription
of Leonardo's notes makes clear his
engineer's practicality in saving
time and money: in fact, he even sug-
gests to use plaster instead of refrac-
tory clay for the outside mold.

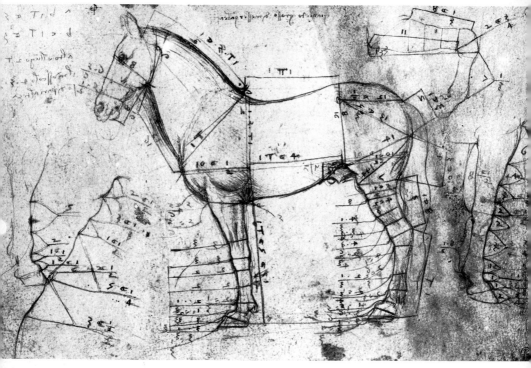

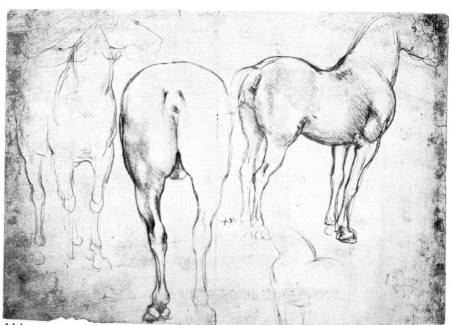

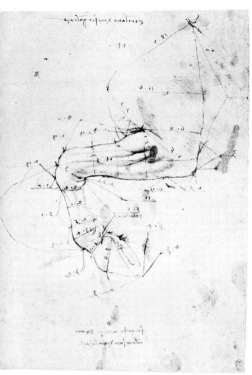

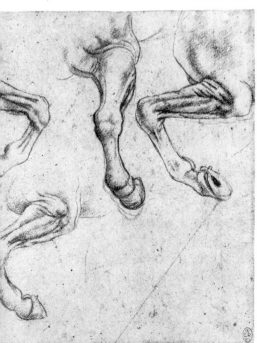

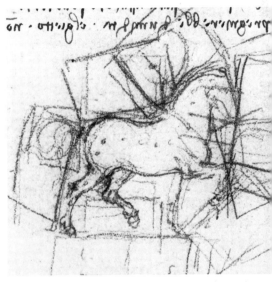

Leonardo may have borrowed ide[...]
other equestrian monuments, but h[...]
mately referred to nature. In the duca[...]
bles in Milan he studied horses, sketc[...]ng
their movements and structure and measur-
ing the parts of their bodies to establish
precise proportions. In the drawing at far
left, Windsor Collection 12319, he divides
the horse into sections and jots down meas-
urements. At left, Windsor 12294, he meas-
ures the foreleg of the Sicilian horse that
belonged to Lodovico's son-in-law Galeazzo
di Sanseverino. Below left, Windsor 12317,

he sketches the hindquarters and two other
views. Here (left), Windsor 12299, are flexed
forelegs – originally drawn by Leonardo but
here in a copy, probably made by his pupil
Francesco Melzi.

Drawings like that above from Codex Mad-
rid II reveal the gait that Leonardo appar-
ently had settled upon for the Sforza horse –
a brisk walk with left hind leg advancing
and right foreleg bent almost at a right
angle.

115

the wax and the whole is heated in a casting pit so that the wax runs out (hence, lost wax). Molten bronze is then poured into the cavity left by the wax. This system accompanied the practice of casting the work, even of medium proportions, in several pieces, which were soldered together, trimmed, and integrated when casting was complete.

At the beginning of the 16th century, soon after Leonardo's work on the Sforza horse, Pomponio Gaurico (or. in Latin, Pomponius Gauricus) discussed the lost-wax method and pointed out its drawbacks. Although the system Leonardo devised to cast the Sforza monument was aimed at eliminating the drawbacks of the lost-wax method, Gaurico seems unaware of Leonardo's system.[22]

The solder lines, or sutures, were ugly traces of the lost-wax casting method but the fact that the model was destroyed or lost was a worse aesthetic drawback, since it meant that the original could not be consulted to eliminate every imperfection when trimming the cast figure.

There were practical as well as aesthetic drawbacks to the lost-wax method. It was impossible to obtain a homogeneous thickness of the modeled wax and if the wax was not evenly thick, then the thickness of the bronze could not be controlled. With no control over the thickness of the bronze, it is impossible to predict exactly the amount of bronze needed for casting. This constitutes an incredible technical problem, especially when it involves a figure of great proportions to be melted in a single casting, which is exactly what Leonardo had in mind.[23] For the Sforza project it was necessary to keep the weight of the mammoth statue as low as possible by reducing the thickness of the bronze. It was also necessary to calculate the quantity of metal precisely, for it would have been an irremediable drawback to find that the molten bronze in the ovens was insufficient to complete the casting. It was thus completely necessary for Leonardo to reject the lost-wax method, but it is also necessary for the modern reader to remain aware of the boldness of his proposal to cast an immense monument in a single operation using an entirely new and unproved method.

Codex Madrid II is the link that, after years of loss, joins the modern reader to Leonardo's plans and experiments for this radical departure from casting traditions. Unfortunately, since Leonardo did not take notes in sequence, but rather wrote down what came to mind on whatever scrap of paper came to hand, the interpretation of his record of the casting process is not completely verifiable.

116

In order to reach a clearer understanding of the casting process, it is helpful to refer to the notes in the Codex Atlanticus and the Windsor Collection, including notes for the monument planned for Gian Giacomo Trivulzio.[24]

Leonardo's new plan for casting the enormous bronze horse began with the full-size earthen model in the old courtyard of the castle. Directly over the earthen model he made an impression in several pieces which would become the female section of the mold. The drawing on folio 157 recto of Codex Madrid II (p. 125), of the head and neck of the horse, shows several pieces closed together over the model and held in position by iron rods. The pieces making up this mold, or form, would vary in number depending on whether they were placed on a flat or round part of the model. The codex reads, on 148 recto, paragraph 2, "You should prepare a form of three parts for each roundness of any of the limbs; it will be much easier to detach it from the earthen horse." The interfaces of the pieces were traced on the model appropriately greased; following this operation, the various pieces were strengthened by drying, detached, and then reassembled. There would thus be a hollow female mold in two halves, referred to as a "half and half mold."[25]

Within the hollow of this half and half mold, a homogeneous layer of a malleable substance was laid. This layer is referred to by Leonardo in Codex Madrid II as the "thickness." The thickness (later referred to by Cellini as *lasagna*) was to have been made from an earthen material or wax. On folio 144 recto, paragraph 6, he mentions making the thickness of potter's clay and on folio 148 recto, paragraph 6, he refers to wax or potter's clay. The thickness was Leonardo's solution to the problem of calculating exactly the amount of bronze that would be needed. The ratio between the weight of the material used for the thickness and that of the bronze would make it possible for that calculation to be precise. Beneath it, in the hollow of the female, would be the male, made from refractory clay used by foundrymen and specially heat-resistant so that it could withstand baking and direct contact with the molten metal. This male mold would be constructed in relation to the iron gaggers that held it steady within the hollow.

There were two categories of gaggers positioned in the hollow of the mold: the first would remain in place after casting to give greater stability to the completed bronze monument; the second set of gaggers functioned to support the core and the outer casting layer in position and would be removed once casting was completed. Sketches and descriptions of these gaggers can be found in the Codex Atlanticus (datable to 1494)[26] and also in Windsor 12349 where the sketch of a mold for a rearing horse shows that Leonardo had been planning this new molding system during his first years in Milan working on the initial stages of *Il Cavallo*.

It was vital that the male mold be completely moisture-free. To ensure that, Leonardo planned to liberate it from the female mold and rebake it, in a process similar to that used by cannon founders. Leonardo could rely here on his previous experience as master of artillery in Florence, and from this he was well aware of the serious difficulties that might arise if the moisture were not completely eliminated from the male. To avoid this, he proposed another modification of the casting process.[27] He planned to make a layer of refractory clay, only 8 inches thick, to fit the hollow of the female mold. This would be the most superficial part of the male, forming an "envelope" which, after rebaking, would be filled with a mixture of brick dust, ash, gypsum, or lime mortar.[28] An "outlet" left on the inside would then ensure the discharging of any residual moisture still left at the moment of casting. Although Leonardo planned to use this process for the body of the horse, *Il Cavallo*'s mold of the head and neck was to be at once completely filled with the refractory clay of the male.

The layers of the mold at this stage are the female and its now joined interfaces, which could be closed around the male. This would essentially provide for a more

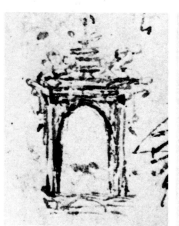
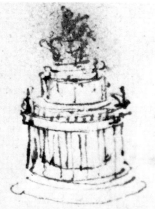

The Trivulzio project was conceived as a much more elaborate funeral monument than the Sforza horse. Only one sketch datable from the years of the first drawings for the Sforza monument, from Codex Atlanticus, folio 148 recto-a, deals with a base for the life-size statue of Sforza, a high pedestal with arches underneath (above left).

For the Trivulzio, Leonardo planned a life-size horse and rider on a large ornate marble pedestal. In the sketch above right, Windsor 12355, the base is a sort of triumphal arch. In the center sketch above, Windsor 12353, the base is rounded and supported by many columns.

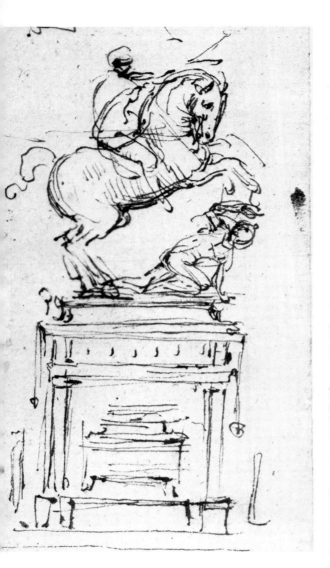

In the sketch at right, Windsor 2353, the pedestal rests on Doric pillars at each corner, and nude athletic figures perch on the sides. Several studies for the Trivulzio monument made use of an old sculptor's trick: resting the forelegs of a rearing horse on some objects. For Donatello's Gattamelata it was a large ball. Tradition has it that even the Marcus Aurelius originally was balanced on a prostrate enemy warrior which long ago disappeared. In his sketches Leonardo opted for the fallen foe. The kneeling enemy attempts to ward off the hoofs with his right hand. The base has a cornice with the marshal's trophies dangling from it and a Tuscan column at each corner.

elaborate version of the prevalent method of casting, but would still have many of the drawbacks of that method. There would be no way of checking the faithfulness of the impression made from the earthen model, and there would undoubtedly be many imperfections resulting from the elimination of the thickness, the repeated removals of the hollow pieces, and the many sutures between pieces.

The greatest achievement of Leonardo's new system of sectional molding was that a hollow plaster impression was obtained in which it would be possible to cast wax to obtain a countermodel of the original. The artist could check this countermodel for deficiencies that might have occurred in the first impression, correct them, and trim the countermodel until maximum perfection in the image to be translated into bronze had been achieved. The molding process was thus no longer a matter of high-level manual labor, but rather a creative work that demanded the presence and intervention of the artist.

The folios of Codex Madrid II do not explicitly mention a wax countermodel, but it is hinted at, especially in the Codex Atlanticus: ". . . pour the rest [that is, of the wax] . . . and then trim the wax as you require. . . ."[29] Even though the wax countermodel here clearly described is for a figure of small proportions, it is extremely unlikely that Leonardo would not have tried to produce one for a project requiring such care as the Sforza horse, the more so as we know that he will include a wax countermodel in his estimate for the monument to Trivulzio.[30]

Other evidence from Codex Madrid II seems to allude to the probability of this wax model. Folios 142 verso, 148 verso, and 150 recto mention the necessity of calcination of the horse before covering it with the casting hood. Had this been an earthen model, it would have been covered with a greasy substance to avoid the adhesion of the soil of the hood. But when the casting hood is composed on a wax model, a calcination process is needed instead. Leonardo recommends, "Once you have applied 2 coats of ashes and wish to begin working on the form, rub the surface of the dried coat of ashes slightly with your hand, smoothing it out so that the form does not retain the imprints of the brush strokes."[31]

Considering all the information, it is clear that Leonardo must occupy an extremely important position in the history of the technique of casting: this piece-molding process with a wax countermodel asserted itself everywhere from the 16th century on, and was to remain in use until modern times.
The casting hood itself was fastened with large cross irons that immobilized the male within the hood. This is clearly illustrated by the drawing on folio 157 verso

of Codex Madrid II which shows that the supporting gaggers were anchored to these large iron bolts. Folio 154 recto of Codex Madrid II has a drawing of the frame used for transporting the mold, which indicates that the casting hood was an "open" one, that is, one made in pieces which could be removed from the male after the liquefied wax of the countermodel had been melted away.

This open casting hood was not in general use, but indicates yet another measure designed by Leonardo to solve the challenge of *Il Cavallo*. In casting a monument of such enormous proportions, the casting pit itself posed problems. The pit would have to be fairly deep, and the subsoil in the area of Milan contains water-bearing strata close to the surface. This moisture would, of course, be a clear threat to the casting process. On folio 151 verso, dated December 20, 1493, Leonardo states that if the horse were to be cast upside down, "the water would be as close as one braccio." Thus the casting hood would have to be perfectly dried and waterproofed. The codex describes Leonardo's experiments to demoisturize the hood.[32]

It is clear that the hood was an open one, since it was taken off the male for the baking and tightening process necessary to dry it out fully. This solution is again similar to that which would be used in artillery making, and it would appear that Leonardo's knowledge of making firearms was once again extremely useful.[33]

The hood was probably made of fewer pieces than the other mold pieces since, in contrast to the earlier stages, its removal was made easier by the fact that the pieces did not adhere to the model but, after the outflow of the wax of the countermodel, were isolated from the male by the cushion of air that was later to be occupied by the bronze. The codex discusses the removal of the casting hood "done evenly"[34]

This wooden "cage" – with a faint outline of the horse mold visible inside – was Leonardo's method for transporting the huge mold to the casting pit. His note – "all the heads of the bolts" – refers to the holes along the side of the horse into which he would anchor bolts to secure the inner and outer molds. ATLANTICUS 216v-a

Opposite page:
Leonardo writes his own description for this device, which he would use to transport and to lower the form; see transcription above.

by pulling it horizontally and uniformly. Leonardo was concerned also with the weight of the hood[35] because of the pulling and shifting necessary for removing it from the male after the countermodel process and transporting it to the casting pit and reheating ovens. Since the hood was heavy, awkward, and rather fragile,[36] it was important to have the ovens and pit at the same site. Clearly, this site could not be at the palace, and for that reason Leonardo designed the frames exemplified by

122

*This instrument is used to transport and to lower the form. And should
you desire to lower it upside down, remove the cross-piece that is used
for tying the instrument together and, reinforcing it on the side nearest
the form, pull at the feet of the beams that support the half-form at points
a and* b. *However, it would be preferable to detach the half-form; pull it
out; and fasten it to the entire instrument, carrying it to the place where
it shall be lowered. And in this way, you shall fasten it in an upright,
perpendicular position. Then, carry the instrument to the opposite part
and, with the frame facing the instrument, secure the form. Once it is
lowered with the aid of ropes, turn the form over, face down. You shall
proceed further, without any change in the instrument of the form.*

<div align="right">MADRID II 154r</div>

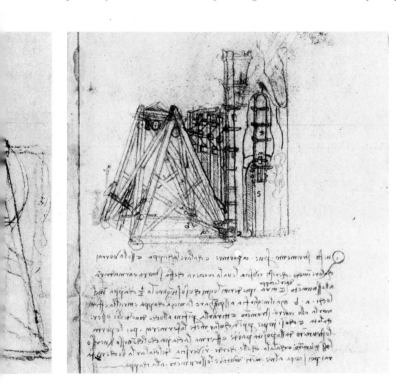

the drawings on folio 154 recto of Codex Madrid II and folio 216 verso-a of Codex
Atlanticus.

The ovens were to be buried at the sides of the pit, and would first be used for
rebaking and waterproofing the two halves of the hood. After this operation, the
male would have to be lowered to the inside, fitted with the channels, or

<div align="right">123</div>

"mouths," necessary for casting the molten bronze.[37] To do this, Leonardo designed a special set of winches.[38] The hood would then be closed over the male, and the entire mold would be laid at the bottom of the pit.[39] This was the final stage of the most complex molding system ever elaborated, revolutionary in comparison with traditional techniques, and proving its superiority by its eventual general use.

Sadly, Leonardo was never to see his elaborate process completely tested. It is known, by a letter of Lodovico Sforza's brother-in-law Ercole I d'Este, the Duke of Ferrara, to his ambassador in Milan[40] that the mold for casting the horse was completed. That letter was requesting the mold for an equestrian monument to Ercole himself. Italian politics had turned again, and events beyond his control prevented Leonardo from further work on *Il Cavallo*.

From the notebooks, it is not difficult to imagine Leonardo, absorbed in his experiments, poring over designs, uninterested in court intrigues. Unfortunately, those intrigues ultimately threatened his magnificent project. Il Moro's position as Duke of Milan had never been satisfactorily secure. He was threatened by his nephew Gian Galeazzo, whose wife had powerful relatives in Naples. Neapolitan actions against Milan were discreetly followed by Florence, and Lodovico was confronted with the possibility of an Italian coalition directed against Milan. In 1494 Gian Galeazzo died, perhaps murdered at Il Moro's instigation, and in the same year, about the time that Leonardo was preparing the final molds, Lodovico persuaded King Charles VIII of France to prosecute an old French claim to Naples. This at first appeared to be a master stroke of political manipulation, but the results were disastrous to Il Moro. It is quite possible that he intended the French to remain a menacing threat only to the other Italian powers. In any case, it soon developed that France seriously intended to invade Italy, Milan included. Lodovico's brother-in-law in Ferrara was directly threatened. In November 1494 Il Moro was forced to use the 158,000 pounds of bronze designated for *Il Cavallo* for cannons.[41]

Leonardo did not abandon hope at this time. He was painting the *Last Supper* when he wrote to Il Moro, "Of the horse I shall say nothing because I know the

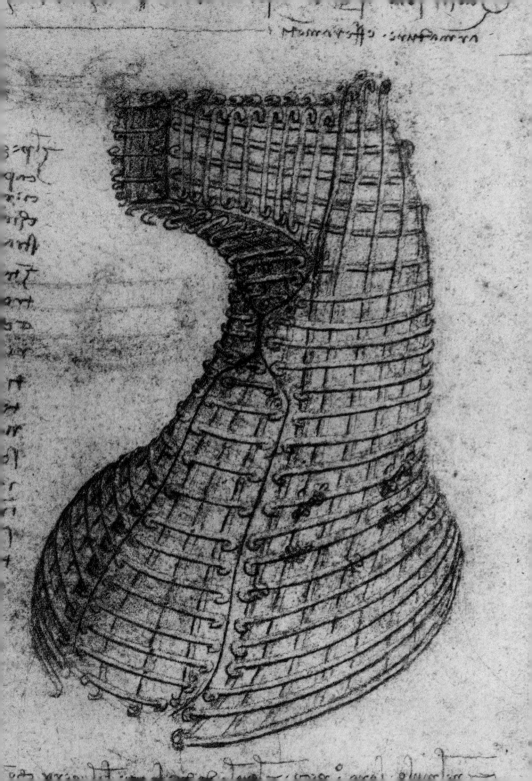

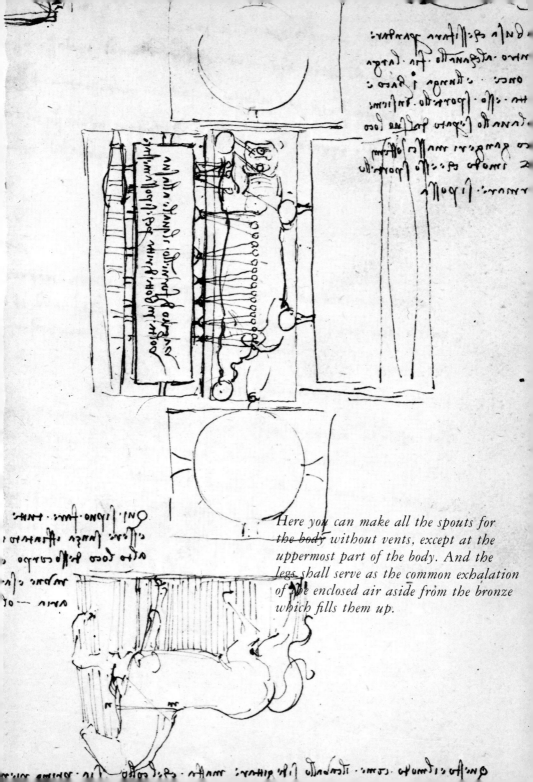

Here you can make all the spouts for the body without vents, except at the uppermost part of the body. And the legs shall serve as the common exhalation of the enclosed air aside from the bronze which fills them up.

times. . . ."[42] Leonardo in his final plans for the casting decided to cast the tail separately from the rest of the horse, because of the difficulty in making the bronze penetrate into the individual tufts.[43] Although he had decided earlier to cast the horse on its side to avoid the dampness near the bottom of the casting pit, he changed his mind and decided that he could cast the horse upside down as he had originally planned.[44] He also worked on the design of the ovens, and drew, on folio 149 recto of Codex Madrid II, a total of four – two circular and two rectangular (p. 126). Folios 142 and 148 discuss an intention to use even five or six ovenloads of bronze at a time, with one oven for each part of the horse. He was forced to stop, however, in 1499 when the troops of Louis XII were besieging Milan. Leonardo left with Luca Pacioli, his mathematician friend, for Venice and eventually for Florence. The enormous earthen model of *Il Cavallo* in the palace courtyard was used for target practice by Gascon archers after Lodovico's capture and incarceration in a French dungeon. The request by Ercole d'Este for the molds for his own monument was later vetoed by the King of France. Every trace of the casting mold was to disappear.

Leonardo occupied himself readily with other projects in Florence, and then in work for Cesare Borgia. Nearly a decade after he left Milan he was commissioned to create another equestrian statue by Gian Giacomo Trivulzio (p. 99), the Italian-born commander of the French troops who had taken Milan from Il Moro. Here Leonardo worked on the problem of designing a life-size monument in bronze that would be practically possible to cast and at the same time reflect the liveliness of posture of an animated horse. Leonardo prepared a number of

This is Leonardo's graphic vision of the casting pit for the Sforza horse. In the center, in a view from above, is the assembled outer mold of the horse. It is flanked on four sides by multiple furnaces – two rectangular and two circular – of the type he had designed for casting cannon to melt the bronze before it flowed into the mold. He could calculate how much bronze would be needed because he knew how much wax or potters' clay – which was used for the "thickness" – already had occupied the space between the outer and the inner molds.

Tubes connecting one of the furnaces to holes in the mold carry the molten bronze. In a note transcribed here he refers to the fact that some of the tubes – "spouts" – would have to be vented. The sketch at the bottom shows "how the horse shall be cast" – upside down. The diagram and note at top right describe a hole about 12 by 23 inches for getting inside the finished horse. Through this hole would be removed the earthen materials that had formed the inner mold during casting. MADRID II 149r

exquisite sketches (pp. 110, 118, 119, 132) for the Trivulzio monument (especially in the Windsor Collection), but unfortunately, this horse too was never cast in bronze. Leonardo never saw his plans and designs realized.

It is more than likely, however, that some handwritten copy of Leonardo's writings on casting existed. Benvenuto Cellini was supposed to have bought in France a transcription "in pen" of a Leonardo book "on the three great arts: sculpture, painting, and architecture."[45] Whether from this book or some other source, Leonardo's exact casting system was put to use some 200 years later. Germain Boffrand[46] and others describe the system followed by Jean Baltazar Keller of Switzerland in molding and casting the huge equestrian monument of Louis XIV that was erected in Paris in 1699 from a model created by François Girardon. There are remarkable coincidences between Leonardo's procedures and those followed for the French statue. This monument is in fact the first historically documented example of a figure of exceptional proportions executed in a single casting, that is, just as Leonardo had planned for the Sforza horse. Besides this, we note in Boffrand some expedients elaborated by Leonardo and not mentioned either by Vasari or by Cellini, such as the "s" shaped irons worked out to support the earth of the male inside the female mold, or else the precaution of striking the male mold with a piece of wood in order to make sure that no lesions exist. In addition, the sketch traced by Boffrand of the "upside down" horse enclosed in the plaster piece mold is remarkably close to Leonardo's drawing of the Sforza horse in its casting pit – even the figure of the horse itself is similar to the Sforza monument (pp. 130–131).

But this statue, although realized in bronze, was also destined for destruction: it was one of the great, but royalist, works of art torn down in the French Revolution.

Leonardo's work and designs for the Sforza horse then disappeared until 1967, when Codex Madrid II was rediscovered in the Biblioteca Nacional in Madrid. The importance of the section of the codex on *Il Cavallo* cannot be over-emphasized, for it clearly establishes Leonardo's great contribution to the history of casting sculpture. Additionally, it records the work of Leonardo, confirming our image of him as artist, scientist, and innovator struggling with the fluctuations of Italian Renaissance politics, creating works of art that endured longer than the reigning monarchs he worked for, and designs that were put into practice long after the powerful princes of his era had been forgotten.

And yet there is a sadness to this project that symbolizes a man trapped in times that do not permit him his fullest growth or award him his due recognition.

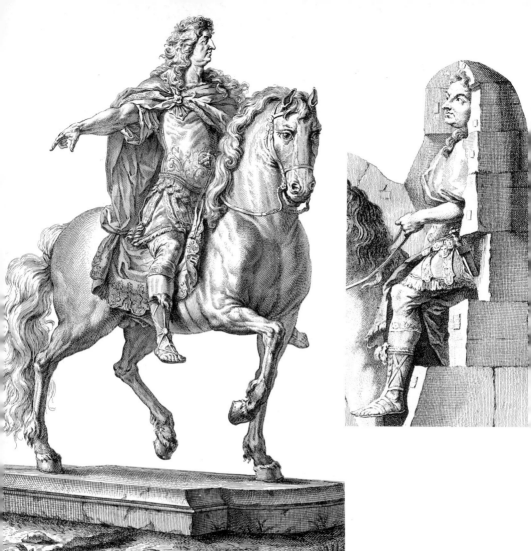

Leonardo's new casting system was put into practice for a large-scale monument 200 years later. This statue of Louis XIV is the first known example of a huge figure being made in a single casting. It was erected in Paris in 1699 while the great Sun King was still in the midst of a reign that lasted 72 years. In casting the statue the foundrymen followed the same procedure Leonardo had envisioned, preparing the mold and pouring the bronze in one casting. Even the figure of the horse itself – from a model created by François Girardon – bore a remarkable resemblance to the final drawings for the Sforza horse. The French must have heard of Leonardo's ideas through word of mouth or through handwritten copies of his notes. Cellini is supposed to

The illustration at right represents the mold in plaster which is the female mold of the original plaster model.

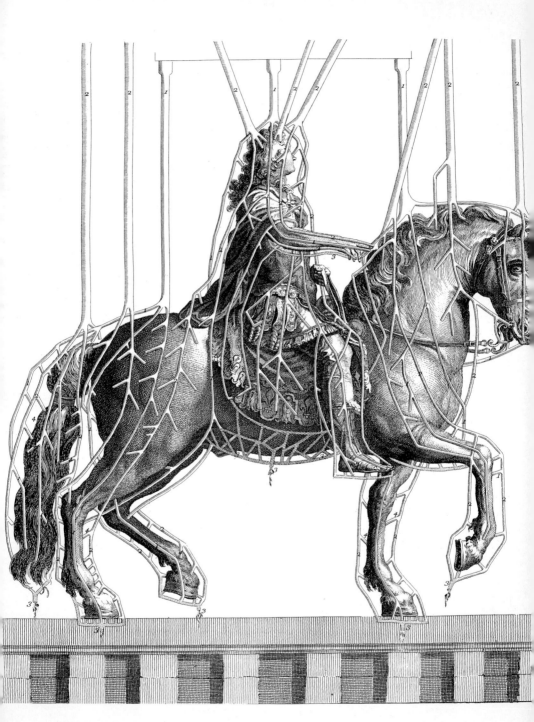

The similarities between Leonardo's new casting process and the method used 200 years later in making the monument to King Louis XIV can be documented by a comparison of manuscripts. The illustration at left, taken from an 18th-century report on the casting of Louis XIV, shows the wax countermodel of the horse and rider. The network of tubes served two main purposes. First, they allowed the wax that had been laid in the hollow space between the outer and inner molds to drain out when heated (drops of wax can be seen draining from the bottom openings of the lower tubes). Second, they permitted pouring of the molten bronze into the space vacated by the wax. The diagrams at top and bottom are comparable views, Leonardo and Louis XIV, of the casting process. At top is the view from above the casting pit. Leonardo's diagram (top right), a detail from Codex Madrid II, folio 149 recto, shows casting tubes leading to a rectangular furnace. At bottom is a comparison of the rear views. In Leonardo's sketch (bottom right), Windsor Collection 12351 verso, the shaded area represents the hollow space, which is occupied by the wax, then the bronze. The tail is missing because

he had decided to cast it separately. In the drawing for the French statue (bottom left) the metal gridwork spanning the inner mold was designed to reinforce the cast horse after the materials of the inner mold were removed through a hole.

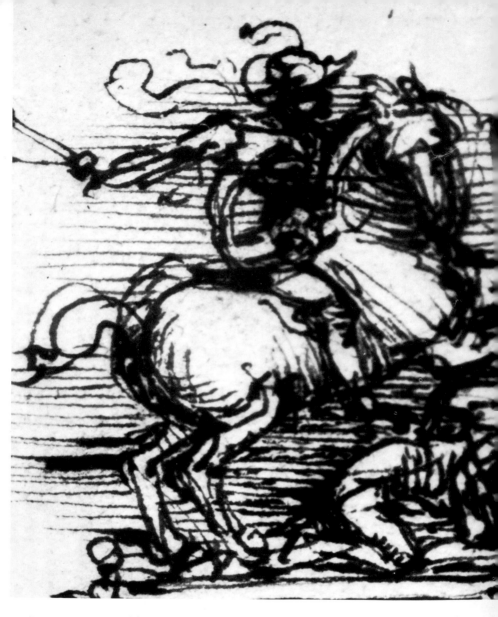

Perhaps this sense of disappointment, of isolation, is best expressed by Leonardo's own words on folio 141 recto of Codex Madrid II: *"Epitaph*

> *If I could not make*
> *If I"*

A study for the Trivulzio monument, with the rearing horse resting its forelegs on a vanquished enemy. (Windsor 12355)

*Again, the bronze horse may be taken in hand, which
is to be to the immortal glory and eternal honor
of the prince your father of happy memory, and of the
illustrious house of Sforza.*

These statements sum up in his words the
tragic story of Leonardo and Il Cavallo.
Above, in 1482, he writes to Lodovico
Sforza offering his services.

*Of the horse I shall say nothing because I know
the times. . . .*

A later letter to Lodovico refers to the "times"
– the duke's regime is in trouble and the
158,000 pounds of bronze intended for
casting the horse have been sent to Ferrara
to be made into cannon barrels.

*The Duke has lost his state and all of his
possessions and his liberty and has seen
none of his works finished.*

Leonardo writes in his notebook a kind of
epitaph.

*Epitaph
If I could not make
If I*

This "epitaph" ends Leonardo's notes about
the horse in Codex Madrid II. He "could
not make" the horse because of war – rather
than because of his own restless striving to
create technology that was new, better, and
more difficult.

*Today only Leonardo's notes and drawings
for the horse survive. The molds were made.
They disappeared. Even the wonderful
earthen full-scale model of it was lost – to
the arrows of the French invader. But in the
illustration on p. 135 Leonardo's horse lives.
if only in symbol. His drawing from Wind-
sor 12347 has been enlarged and placed
upon a schematic base, the size and place-
ment of which, however, is merely a specula-
tion. The monument is projected into the
courtyard of the Sforza Castle, the proper
proportions having been taken into con-
sideration. Now, Il Cavallo looms majesti-
cally over the ducal courtyard, probably close
to how Leonardo must have envisioned it.*

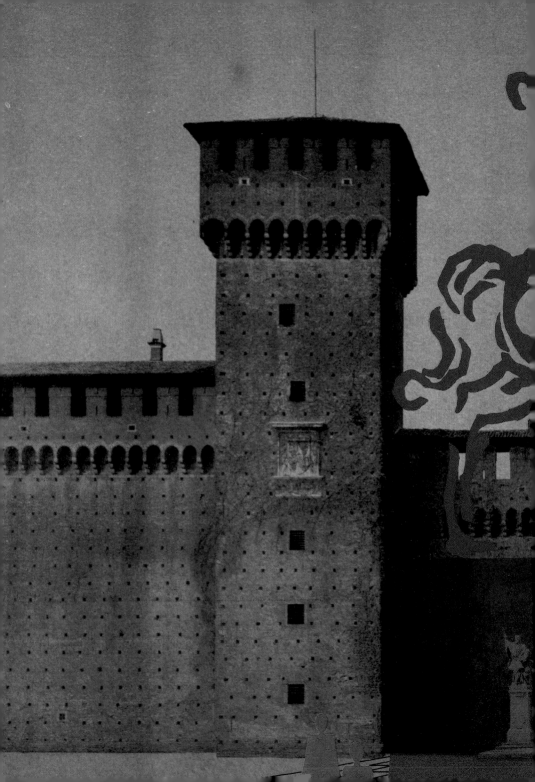

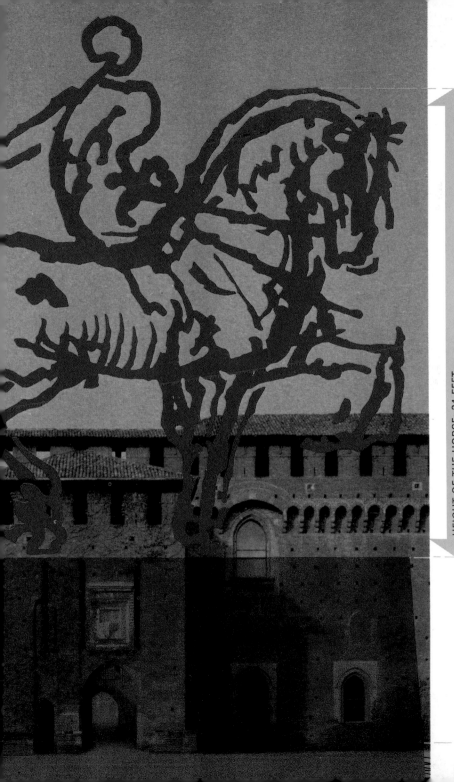

HEIGHT OF THE HORSE: 24 FEET

HEIGHT OF THE BUILDING: 62 FEET

"Those enamored of practice without
science are like a pilot who goes
into a ship without rudder or compass
and never has any certainty where he is going."

THE TEACHER

ANDRÉ CHASTEL

TRATTATO
DELLA PITTVRA
DI LIONARDO
DA VINCI,

Nouamente dato in luce, con la vita dell'istesso autore, scritta
DA RAFAELLE DV FRESNE.

Si sono giunti i tre libri della pittura, & il trattato della statua
di Leon Battista Alberti, con la vita del medesimo.

IN PARIGI,
Appresso GIACOMO LANGLOIS, stampatore ordinario del rè Christianissimo, al
monte S. Genouefa, dirimpetto alla fontana, all'insegna della Regina di pace.
M. DC. LI.
CON PRIVILEGIO DEL RE.

Leonardo's Treatise on Painting was published in Paris in 1651 – 132 years after his death.

At a certain point in his career, toward 1489–1490, Leonardo began to draw up his observations with a view to writing a didactic work.[2] The project developed, and according to Paolo Giovio,[3] some partial collections, such as the "book on anatomy," were ready to appear even with illustrations. Leonardo was convinced, like Alberti, that matters relating to art and especially to painting are subject to demonstration – that art can be explained. Alberti (p. 138) died in 1472; the period of his reflection on the arts is that of the second quarter of the 15th century. The timing of his work enabled him to formulate new concepts and precise guidelines in matters not only of painting (*De pictura*, 1436), but also of sculpture (in *De statua*, a small opus drawn up towards 1464) and architecture (*De re aedificatoria*, partly drawn up in 1452 and printed in 1485). Nonetheless, as J. Schlosser has correctly observed, the effect of these writings on the artistic movement is difficult to grasp; and only in 1547 in Venice was an Italian version of Alberti's *Treatise on Painting*, so vivid and so clear, to be printed.[4] The same is true of the small opus on sculpture and the treatise on architecture: their diffusion became general only toward the middle of the 16th century. In the meantime, other theoretical works had appeared, including, in 1504, the *De sculptura* of

137

Gauricus and, beginning in 1486, many editions of Vitruvius.[5] This situation is quite revealing: it is as if Alberti's works were a century overdue in acquiring their authority. Until the mid-16th century they had been unevenly known and admired.

Thus during the 30 years from 1490 to 1519 Leonardo was able to undertake the same task as if nothing had happened. No codified and universally accepted rules existed. And in any case, Alberti's works belong to the productions of the humanist milieu and reflect its ideas on the arts. Only indirectly do they reflect those of artistic circles, and so they do not constitute a satisfactory expression of

One of the inspirations for Leonardo's Treatise on Painting *was the work of the architect and scholar Leon Battista Alberti.*

In his first dated pen drawing (right) Leonardo revealed at age 21 the extraordinary feeling for landscape that would mark several of his greatest paintings. Perhaps sensing its importance, Leonardo noted the date in the upper left corner, "Day of St. Mary of the Snows, August 5, 1473." The German scholar Ludwig Heydenreich has termed the drawing "the first true landscape in art." UFFIZI, FLORENCE

what can be termed "the culture of the workshops."[6] However close his links with artists may have been, Alberti always seems like a great amateur beside the professional men, the craftsmen and the artists trained in his *bottega*.

Leonardo's starting point is appreciably different from Alberti's and even entails a move in the opposite direction. He was 20 years old when Alberti died. Despite all his gifts, he did not have the intellectual and social standing that would have allowed him to compel recognition. He still had to make a success of his career as an artist and to complete his philosophical education.

The original situation of a workshop like Verrocchio's and the very climate of Florence at that time favored in an exceptional way what Panofsky calls the "decompartmentalization" of the disciplines.[7] Members of the Medici circle now

intervened in artistic matters much more than they had during Alberti's youth, and they developed an impure Platonism, impregnated with aestheticism, which young Leonardo could neither adhere to fully nor withdraw from completely. The *botteghe* had become little centers of scientific study: anatomy and perspective were not taught at the *Studio* but at Verrocchio's and Pollaiuolo's. Empirical, technological knowledge needed to be systematized, but a conceptual framework

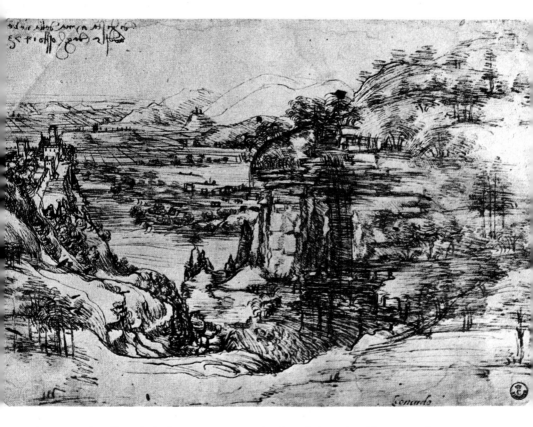

and appropriate linguistic forms were required, and the scientific texts of antiquity and even of the Middle Ages only partly provided them.[8]

During the last quarter of the 15th century it can be observed that in all the centers of the peninsula the great heads of workshops – Piero della Francesca, Mantegna, Bramante, the Bellinis – endeavored to raise the professional status of artists by breaking the traditional distinction between the *artes mechanicae* and the *artes liberales*. The most enterprising, the most obstinate, the most brilliant of these

Italian masters conscious of their force and of their responsibilities was Leonardo.

Leonardo's entry in 1482 into the court of the Sforzas coincides with an extraordinary program of activity in which the demands made on him as an engineer outweighed those made on him as a sculptor or painter (p. 9). It was in this milieu that Leonardo realized the necessity of composing new treatises, based on the analysis of the scholar and the praxis of the technician. And from 1489 on, scattered notes show the intellectual freshness with which Leonardo approached questions on painting.[9] In 1492 Manuscript A revealed the general lines of the future *Treatise on Painting*. The dedicatory letter placed by Luca Pacioli right at the head of his treatise *De divina proportione* and dated February 1498 mentions it as well, speaking of Leonardo as "having completed with all diligence his great treatise on painting and human movement."[10] Leonardo held up its publication, but continued to study ways to give the work the necessary illustration. This delay, which was fatal to the project, can be explained by the continuous expansion of the investigation and the difficulty of co-ordinating all its various aspects. Nor did Leonardo's return to Florence simplify matters.

We must imagine the favorable climate that surrounded Leonardo there just after the turn of the century: "His fame had grown so great," wrote Vasari, "that all lovers of art, indeed the whole city, wanted him to leave them something to remember him by, and everywhere they spoke of nothing other than to have him carry out some great and wonderful work. . . . " Demands upon the artist were heavy during these years when Florence had regained an artistic and cultural importance not yet disputed by Rome. Everyone was beginning to realize – in Florence as elsewhere – that Leonardo, who was 50 in 1502, was adding to his talent as a painter and to his aptitudes as an engineer the role of a theoretician. At the end of 1504 a rather arid but at the same time informed and complex treatise on sculpture by a lesser-known Neapolitan humanist was published by Giunti in Florence. In the foreword to this work the editor invoked the patronage of Lorenzo Strozzi, who, along with Bernardo Rucellai (who had been Florence's ambassador in Milan from 1484 to 1486, during Leonardo's stay), was the life and soul of the city's most active intellectual circle. Leonardo, too, must have known about these men, and they must have known about Leonardo. In short, if there was a call for a great doctrine, it was in this period that it must have become urgent, when Leonardo was in the limelight.

The fragments found in Codex Madrid II (see p. 150) prove that during these years of frantic activity the undertaking of the *Treatise* again forced itself upon the artist.

Among the paintings of Leonardo that have been lost is his Leda and the Swan, *shown here in one of the several existing copies. The work was said to be executed for the palace of Fontainebleau. Leonardo's notebooks contain preparatory sketches for the painting, some as early as 1506. The copies give some idea of Leonardo's technique where anatomy and landscapes are concerned.*

In 1504 the plan for the *Treatise* went back about 15 years; and Leonardo now had only 15 more years to live. So we are at the center of the 30 years during which Leonardo was obsessed by the idea of the *Treatise*. Never was he to find the leisure or, more important, the frame of mind that would have allowed him to arrange his mass of notes in order and bring the task to completion. The few pages *de pictura* of Codex Madrid II precede by little their elaboration in a collection, Libro A, whose organization is much more solid than all he had composed up until then; it has been brilliantly reconstituted by C. Pedretti, from paragraphs of the Codex Urbinas (see p. 151), where its 107 elements have been transcribed.[11] Each of the painterly themes evoked in Codex Madrid II finds a more advanced development in extremely similar notes in Libro A. This latter notebook dates from the years following 1505, with a certain concentration around 1508. But around 1508 Leonardo's plan for publication lost steam; the project for a treatise on anatomy seems to have broken away from the all-embracing enterprise of the *Treatise on Painting*. It is at this time that he wrote the famous and rather pathetic note excusing himself for being able to achieve only "a miscellany devoid of order,"

These details from the Borghese copy of
Leda and the Swan *demonstrate the impor-*
tance of natural and architectural elements
in Leonardo's larger works. Above all, as he
stressed in his notebooks, these elements
were not to be treated as secondary in
importance, as mere background.

143

In his writings on art Leonardo portrayed painting as "the sole means of reproducing all the known works of nature." The painter, in short, was a kind of god who could create – or at least recreate – the world. In the Treatise on Painting he describes some of the painter's powers:

The painter can call into being the essences of animals of all kinds, of plants, fruits, landscapes, rolling plains, crumbling mountains . . . places sweet and delightful with meadows of many-colored flowers bent by the gentle motion of the wind which turns back to look at them as it floats on

Leonardo rejected the practice of many Renaissance painters who looked at nature as if it were a mere backdrop for their human figures. In the Treatise he attacks

the "very bad landscapes" of Botticelli. The painter "is not well rounded," he writes, "who does not have an equally keen interest in all of things within the compass of painting."

In Leda and the Swan he captured a landscape and a woman bursting with new life. The painting was lost, but numerous copies have survived. The details shown here are from a copy at the Borghese Gallery.

because he could not reread and confront everything. This would have been too complicated a task "especially in view of the great intervals of time separating one moment of writing from the next."[12] It remains true, however, that during the years 1505–1508 Leonardo returned to the theoretical problems of painting.[13]

Leonardo's manuscripts have accustomed us to an incredible diversity and to an often disconcerting intermingling of records. In Codex Madrid II calculations and rough sketches dealing with the deviation of the Arno (from 1503 to the end of summer 1504) or the fortification of Piombino (autumn 1504) alternate with studies for the conversion of volumes and observations on gliding and musical instruments. We also find here and there remarks on totally different subjects, some of which have proved to be of capital importance – such as the note that gives the date of an accident that befell the cartoon for the mural of the *Battle of Anghiari*. This little note (p. 78) serves as a reminder that the period of 1503–1505 to which the manuscript belongs is also – and in a sense is especially – that of the *Battle of Anghiari*, commissioned in October 1503. Leonardo therefore

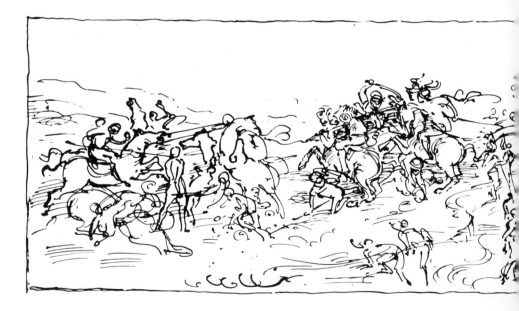

had the notebook at hand during the two years when, in spite of his work as engineer, his mind was on this project of the governing council of Florence. One might have expected it to contain remarks concerning the elaboration of the work. In fact, however, the observations deal mainly with anatomy or how the eye sees –

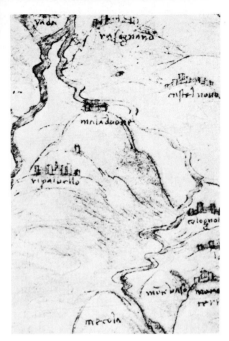

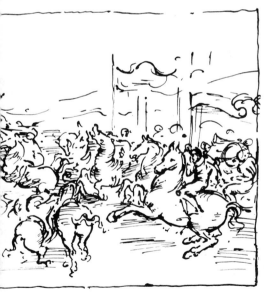

Leonardo never finished his painting the Battle of Anghiari. *It was partially ruined by technical failures; later covered over with another painting. Copies of the* Battle of Anghiari *show only a central group of fighting horsemen. But the vast size of the wall space – about 22 by 58 feet – and a number of Leonardo's studies lead to the belief that he intended a much more panoramic work. The reconstruction at left, which is based on his drawings, shows the central battle flanked on either side by groups of foot soldiers and horsemen.*

Since 1973, research efforts have been under way in the Palazzo Vecchio, Florence, to locate Leonardo's work and remove the mural covering it.

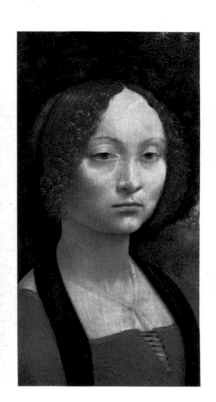

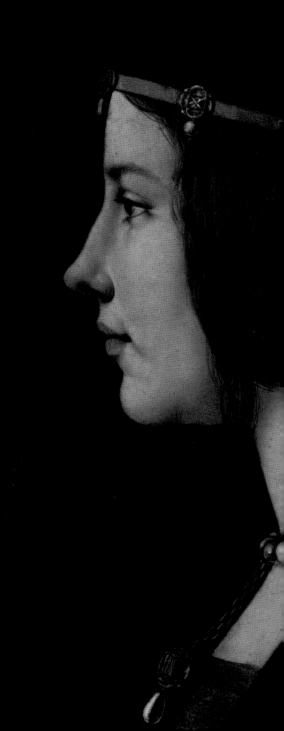

Despite – or maybe because of – Leonardo's apparent lack of real fondness for women, he painted fascinating portraits of them. Isabella d'Este hounded him for five years and never did get a portrait. He had to do some portraits to earn a living and to satisfy his patron the Duke of Milan. He made the task less arduous by adding visual puns to amuse himself. In his first portrait (above), he painted Ginevra de' Benci against a juniper tree – or ginevra.

The Lady with an Ermine
*(above), at the Czartoryski in
Cracow, portrays Cecilia Galle-
rani, one of the duke's mistresses.
The ermine, a symbol of the
duke, represented purity.*
Left: Beatrice d'Este *at the
Biblioteca Ambrosiana in Milan,
is the portrait of the duke's young
wife and Isabella's sister. On her
dress Leonardo — or perhaps a
pupil — added the lacework pat-
tern used in his* Sala delle Asse
decorations.

149

that is, with general problems. These may be connected with the council's complex project, but they only deal with it through Leonardo's customary problem-solving approach.

Apart from the record of the thunderstorm on folio 1, the notes appear on 18 leaves. One note, dealing with perspective, is found at the end of the first quire.[14] All the others are spread out over the internal quires and are distributed in three

areas quite distinctly towards the beginning, in the middle, and towards the end of the collection.[15] There are no special conclusions to be drawn from this, for the same subjects of reflection reappear from area to area: (1) observations on anatomy, (2) observations on the eye, its pupil, and the perception of light, and (3) indications on reflections and the range of color tones.

A recapitulation of the content of these brief notes scattered in Codex Madrid II is enough to reveal the link between them and the problems of the *Treatise*. Its tone, its questions, its turns of phrase are recognizable. What we have here are not unconnected notes or aphorisms, but elements of demonstration. The impression we get is of a scholarly monologue proceeding in the midst of other occupations.

These notes were not afterwards neglected: 14 passages were transcribed into the Codex Urbinas; and all the paragraphs taken from Leonardo's manuscript bear the little sign testifying that they were in fact picked out by Francesco Melzi in the arduous compilation of around the 1550s, which made the belated publication of the *Treatise* possible. Therefore, Codex Madrid II was certainly one of the group of notebooks to which Melzi strove — following Leonardo's instructions — to extract the substance and co-ordinate the passages.[16]

The note at left, from Codex Madrid II, was copied into the Codex Urbinas (right) by Francesco Melzi, in the 1550s, with great fidelity. The passage shown here concerns the varying intensity of light at different points on the body, and thus the location of shadows on the face. In all, Melzi copied 14 passages from Madrid II and put them into the Codex Urbinas, which served as a source work for the Treatise on Painting.

Comparison of the originals and the text recopied into the Codex Urbinas (as above) confirms the faithfulness of Melzi's collating; only two paragraphs have been shortened. Those that were not retained were useless repetitions of notes to be taken from other manuscripts.[17] If 14 passages were taken from Codex Madrid II for the final compilation, it is because this notebook was considered, despite the relatively small number of these notes, as a valid contribution.

Of these 14 passages, 2 must be considered apart. They appear as warnings that the painter is supposed to be giving himself. The first concerns the effect of perspective in great compositions with a strong horizontal extension: "In itself, a perspec-

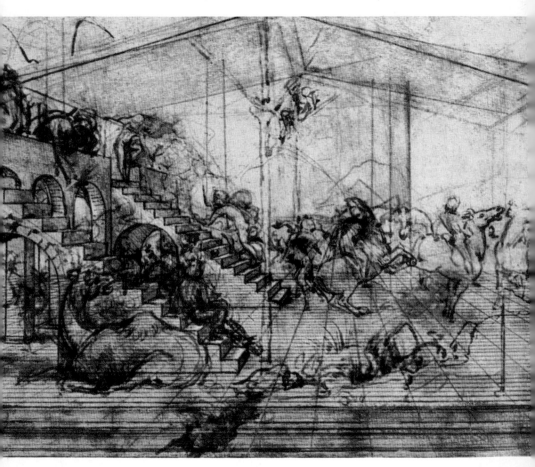

tive offered by a straight wall will be false unless it is corrected by presenting to the beholding eye a foreshortened view of the wall (154–155)."[18] Leonardo is talking about murals. In the case of a long horizontal span, the spectator placed at the center unconsciously discerns the most distant parts as though they were slightly deformed, for it would require a slightly concave wall to maintain all the elements equidistant from the visual focus. The spreading out of forms achieved by the

The same architectural elements – arches and stairs – appear in the background of the Adoration of the Magi (detail below), which Leonardo left unfinished. Although the angle of vision is different, the rules of linear perspective are as rigorously observed as in the preliminary study shown opposite.

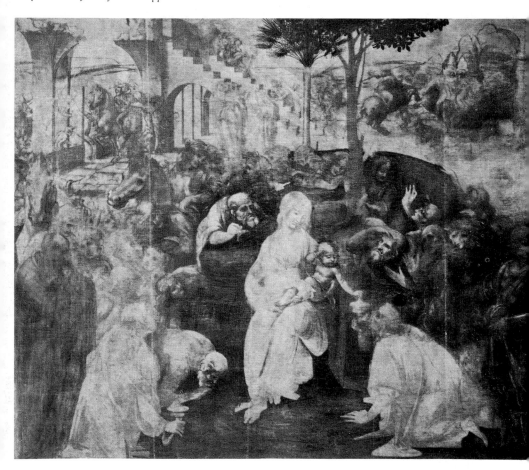

system of "artificial perspective" – which does not take into account this deformation – thus calls for an excessive enlarging of the lateral parts, judging by what one should perceive in nature. Leonardo resolves the difficulty by supposing that a kind of spontaneous correction takes place there; the deformation caused by the projective system of the painter is compensated by the very perception of the spectator placed in the axis.[19]

The reason for his statement in the codex being so laconic becomes clear when we observe that the little explanatory diagram had already appeared in Manuscript A of 1492, that the problem is taken up again in Manuscript D and in the Codex Arundel around 1508, and that it finds a more elaborated formulation in Manuscript E around 1513–1514. The fragment of Codex Madrid II is thus only one of the instances of a reflection that began some 12 years before and was to continue

10 years later. But the composition of the *Battle of Anghiari,* whose probable dimensions exceeded those of the *Last Supper,* gave the problem a strong current interest.

As he became increasingly intrigued by the science of art, Leonardo went beyond the earlier linear perspective (pages 153–154) to investigate how the eye sees. In the sketches on this page he considers the problem of perspective in large wall paintings, such as the Battle of Anghiari. *Like a scientist he works out the optics in the sketches from*

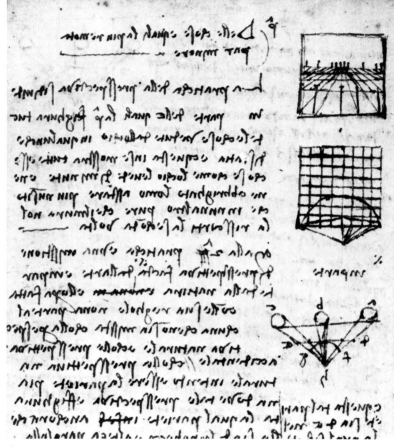

Manuscript E – at top from folio 16 recto, above from folio 16 verso. In the detail at left from Codex Madrid II, folio 15 verso, he notes, "As a rule, the eye looking at a painting on a wall places itself always at the center of the picture." The eye is able to take in a small painting without trouble. But in a wide fresco the figures at each end will be slightly distorted because they are at a greater distance from the eye than is the center of the picture.

The second passage takes on even more clearly the form of a principle: "In narrative paintings never put so many ornaments on your figures and other bodies that they hinder the perception of the form and attitude of such figures and the nature of the aforesaid other bodies."[20] This rule was to be copied into the Codex Urbinas,[21] and in fact bears the mark *de pictura* signifying that it belongs to the *Treatise.* It is not by chance that it appears in Codex Madrid II, for this warning would have little relevance to the *Last Supper,* but it has much for the *Battle of Anghiari.* The composition required a great variety of military armor and equipment (p. 158). What we know of it from Rubens's famous sketch reveals the

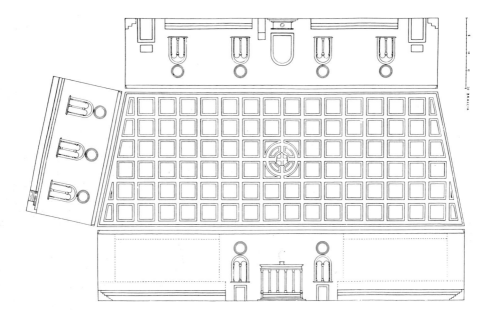

Leonardo painted his fresco of the Battle of Anghiari *in the Sala del Gran Consiglio of the Palazzo Vecchio in Florence (diagram above, bottom left-hand corner).*

Opposite page: *This drawing, with its angry and roughly defined swirl of horses and men, seems to be a study of the central drama of* Anghiari, *the struggle around the standard.*

fantasies that could carry away Leonardo's imagination: the armor decorated with ram's head and the shoulder plate in the form of a spiraling shell, the helmet shaped like a mask, and so on. It seems reasonable to suppose that the remark on ornaments corresponds, like the preceding one on perspective, to a current problem.[22]

The same may well be true of the Codex Madrid II notes relating to anatomy; but these nevertheless fit precisely into the general framework of the future *Treatise*. The one that clarifies the role of the muscles in operations of pushing and pulling defines their mechanism in relation to the seat of the shoulder: "Pushing and pulling are of one and the same nature. . . . Pushing and pulling can be done along diverse lines around the center of the power of the mover. As for the arms, the center is located at the place where the sinew of the shoulder, that of the breast, and that of the shoulder-blade opposite the breast meet with the bone of the upper shoulder."[23] This text is accompanied by rapid little sketches. The idea has been

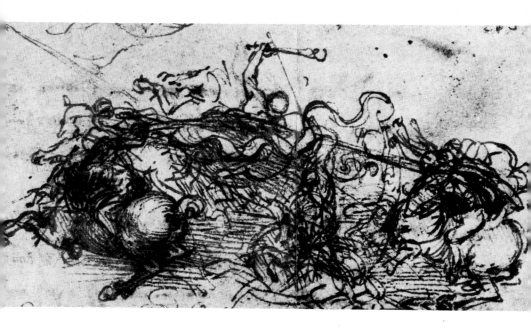

taken up again in the Codex Urbinas,[24] where it is united with other remarks of the same kind on scapular articulation. These notes must be studied on the one hand in connection with Windsor sheets 19003 recto and verso (p. 162), and on the other with the famous drawing in red chalk (p. 166) Windsor 12640, which it is difficult not to relate to the period of the *Battle of Anghiari*.[25] The section of the arm of the two warriors is reminiscent of some ancient marble,[26] and it is only more remarkable to come across the principle again later in the anatomical plates of Vesalius. The embryo of a complete style of presentation of the anatomical "complexes" appears in the drawings corresponding to the passage on pushing and pulling.

In the Treatise Leonardo wrote a self-warning probably related to the epic fresco he was executing in 1504, the Battle of Anghiari. "In narrative paintings," he cautions, "never put so many ornaments on your figures and other bodies that they hinder the perception of the form and attitude of such figures and the nature of the aforesaid other bodies." Leonardo loved decoration, and this detail from Rubens's Louvre copy of Anghiari hints that Leonardo did not heed his own warning. The spiraling decorative motifs on the warrior's helmet and shoulder plate suggest the composition of the battle itself: a compact whirl of violence turning in on itself.

Anatomical analysis, in Leonardo's view, made it possible to rediscover the mechanics that correspond to emotion: the exact image of muscular movements suggests the movements of the soul. Their presentation presupposes, however, an intuitive sense of perception and a feeling for proper balance, both of which Leonardo seems to value above all else. On one page of Codex Madrid II he calls to mind that every muscle varies in volume according to whether it is or is not in action,[27] and on another he says, "Do not make all the muscles of your figures apparent, because even if they are in their right places they do not show prominently unless the limbs in which they are located are exerting great force or are greatly strained. Limbs which are not in exercise must be drawn without showing

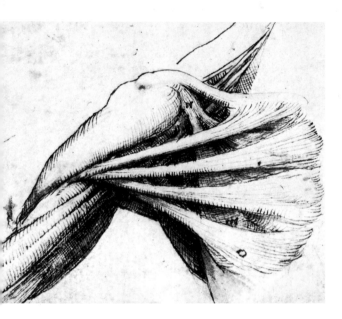

His anatomical drawings were so precise that many are still used to illustrate medical textbooks. He writes, "The painter who has acquired knowledge of the nature of the sinews, muscles, and tendons will know exactly in the movement of any limb how many and which of the sinews are the cause of it, and which muscle by its swelling is the cause of this sinew's contracting."

the play of the muscles. And if you do otherwise, you will have imitated a bag of nuts rather than a human figure."[28] This comparison has a familiar ring about it; the passage has been taken up textually in the Codex Urbinas.[29] From 1490 on we find criticism of "barren and woody figures";[30] the formula of the "bag of nuts" and the phrase "bunch of radish" are applied to nudes that are "woody and without grace" in a passage of Manuscript L which must date from 1502.[31] Since Leonardo attacks numerous artists who were guilty of this abuse, we recognize here one of his polemic stings against a certain widespread Tuscan practice. But an insistent tradition, passing from Dolce (1557) to Lomazzo (1584) and Armenini (1586), has identified Michelangelo as the chief culprit. This interpretation does have some

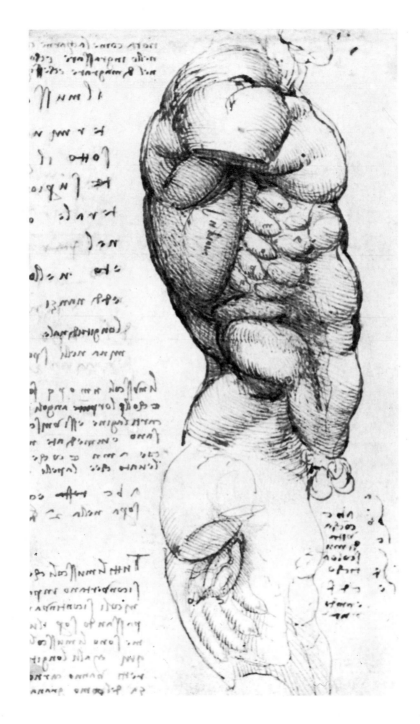

161

foundation: the imprecation reappears in Manuscript E of the years 1513–1514,[32] which we may assume to be a criticism of the nudes of the Sistine Chapel (p. 167). And so the "bag of nuts" of Codex Madrid II may well refer to the *Battle of Cascina* (p. 165), where the display of musculature had taken on incredible proportions. And as Leonardo is at grips with an analogous theme, this no doubt is also a reminder to himself to beware of falling into these excesses.

Leonardo studied the anatomy of men living and dead to learn the mechanics of the body. These anatomical sketches show every muscle. But his painter's conclusion is a preference for "sweet fleshiness with simple folds and roundness of the limbs...." In a little diagram at the right of the lower drawing he contrasts this with the technique of showing bulging muscles. He calls the latter "antique" and his own method "modern".

163

The graceful style that contrasts with the thoughtless anatomical display requires "sweet fleshiness, with simple folds and roundness of limbs," Leonardo says in Codex Madrid II.[33] A Windsor study dating from the same period[34] describes by means of a little diagram how the folds of the skin are formed in the case of knotty muscles and in the contrary case of beautiful rounded shapes. The first formation is called *antico,* the second *moderno.* The same appellations will reappear a few years later, around 1510, in Manuscript G.[35] This time the analysis has considerable extensions and reflects a determined reaction against the harsh style of certain Tuscans. An echo of it is found in Gauricus's treatise *De sculptura* (1504), where the Colleoni horse is regarded as an "anatomical model." Leonardo's critical attitude had decisive consequences everywhere – in Venice, where it combined with Giorgione's trend, in Emilia, and everywhere else that the more relaxed style had paved the way. A sort of cleavage thus established itself between the old style and the modern; Leonardo's terms were taken up and developed by Vasari in the opposition to the "hard, barren, and harsh style" that contrasted with the new way indicated by Leonardo and Giorgione. Vasari's list of the artists of the 15th century who were surpassed by this process gives an account, in a way, of all these artists who "in order to appear great draftsmen, make their nudes woody and devoid of grace." Naturally this list does not include Michelangelo.[36] The transition has thus been made from scientific analysis to aesthetic recommendations: anatomy is the key to the exact representation of the "movements of the soul," that is, emotions. Its use, however, must be based on stylistic requirements, and these requirements are taken into account in the notes of Codex Madrid II, with regard to optics, the basis of the whole painting operation, and the proportions of shadow and light, the regulating of which depends on an essentially artistic choice. Leonardo starts from the analysis of the mechanisms of perception. But in the physiology and even in the anatomy that he adopts, he instinctively – and wrongly – gives the organs of sight a privileged place.[37] So the organ of the eye deserves all the attention: some notes deal with the way in which the pupil reacts to the intensity of light,[38] others with the effect of binocular perception.[39] The model of the *camera obscura,* of the optic box through which the rays travel to produce an image after crossing a narrow opening, seems indispensable to Leonardo. Towards 1508 he will make the analogy clear in Manuscript D, where he will take up all these indications again (p. 169), resuming, through the rapid notes of Codex Madrid II, his previous general studies.[40]

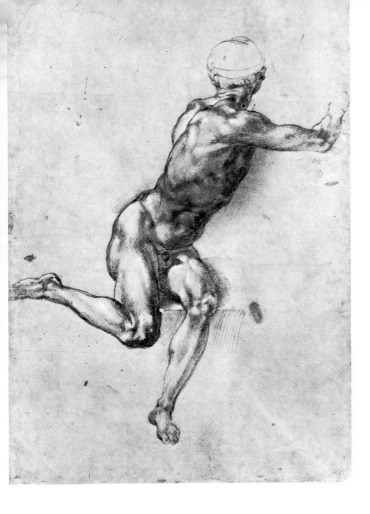

Leonardo and his rival Michelangelo were both masters of the nude. Michelangelo's figures were sculptural, revealing the play of every muscle – as in his studies for the **Battle of Cascina** (above) and a sibyl (see page 167) for his epic painting on the ceiling of the Sistine Chapel. Leonardo at his best could match him in heroic nudes – his sketch (page 166) for the **Battle of Anghiari**, Windsor Collection No. 12640, resembles an ancient marble statue. But Leonardo, switching from anatomy to art, wanted his muscles to suggest the "movements of the soul." Perhaps with Michel-angelo in mind, he writes in Codex Madrid II, "Do not make all the muscles of your figures apparent, because even if they are in their right places they do not show prominently unless the limbs in which they are located are exerting great force or are greatly strained. Limbs which are not in exercise must be drawn without showing the play of the muscles. And if you do otherwise, you will have imitated a bag of nuts rather than a human figure."

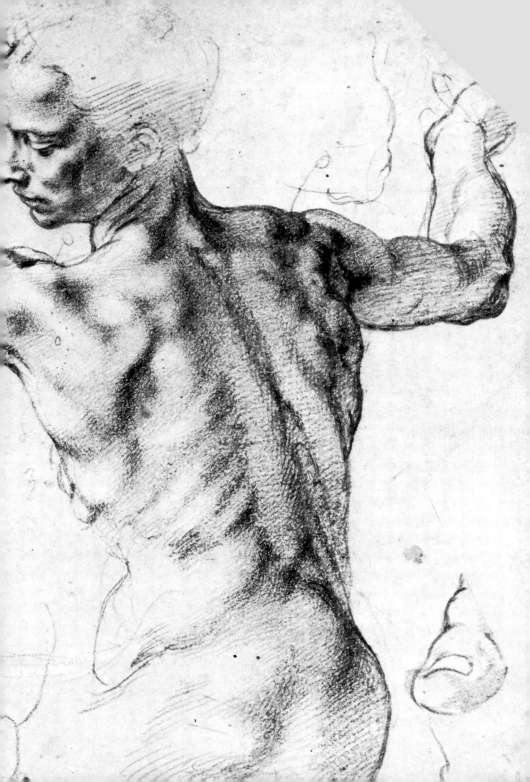

...t possible to analyze plays of light and shadow. In about 1490 a little ... *lume e ombra,* had outlined the laws and variations of the phenome-... Madrid II comes back to it strongly, underlining the importance of the ... about by the density of interposed air, an effect more pronounced ... than in bright ones,[41] the relative blending of dark and bright colors at a distance,[42] and the fullness of color under the prevailing light.[43] To these observations is added advice, in which Leonardo no longer speaks as a physicist who analyzes, but as a painter who chooses: natural light gives more gentle and more enveloping shades than special lighting;[44] there are "places which should be selected in order to give relief and grace to the subjects."[45]

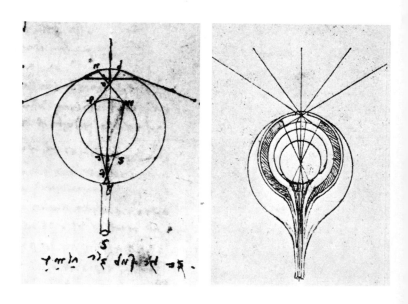

The notes on the whole reveal a completely new attention to open-air effects, which appear to be the fresh stimulus in Leonardo's research. The evidence of Codex Madrid II thus confirms the conclusion reached from the study of the manuscripts already known: towards 1505 Leonardo modifies his approach to the problems of light and shadow and those of color: "he has shifted their study from the inside of the studio to the open air and the countryside."[46] But at the same time he continues as strongly as ever his polemic against violent lighting and oversharp outlines, insisting on the necessity of looking for the right moment and the right arrangement. The same preoccupation will reappear in the famous notes of the years 1508–1510 on "the kind of lighting to choose for painting portraits."[47] In

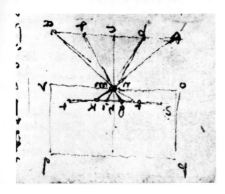

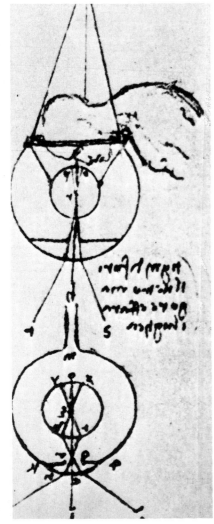

In his optical research Leonardo dismissed the then prevalent notion that the eye saw by sending out light rays. He dissected the eyes of animals and probably of humans. He drew a schematic diagram of the eye (p. 168

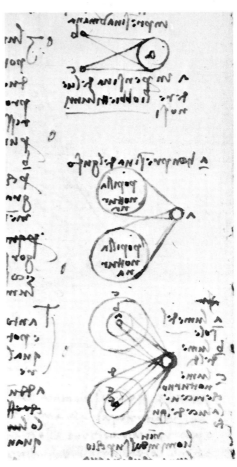

right) in the Codex Atlanticus, folio 337 recto-a, misplacing the spherical lens. He studied binocular perception – above in Codex Madrid II, folio 25 verso. In Manuscript D, folio 3 verso, he created a model of sight (at left) – analogous to the camera obscura, a device that projects an image through a tiny hole – and made diagrams (p. 168 left and top) on folio 8 recto.

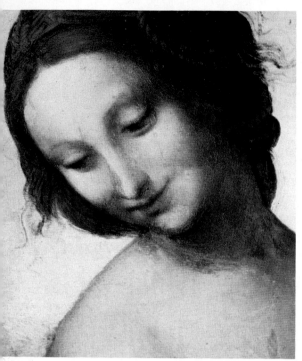

Leonardo's work in optics led naturally to studies of the interrelationships between light and shadow. He goes from his studio into the open air and develops new recommendations, which are then applied in his own practice. He cautions against harsh lighting and outlines that are too sharp. He seeks, in the paintings shown here, a transparency of shadow around the head that relates the figures to their environments. His chiaroscuro is a delicate contrast of light and dark that gives a rounded modeled effect of three-dimensional mystery. Here is a detail from a copy of his lost *Leda and the Swan* (shown at left). At right are details from the Louvre *St. Anne* and the *Mona Lisa*. The subtlety of lighting relates all three women.

Overleaf: Larger detail from a copy of Leda and the Swan.

these analyses of the delicate blend of the shades that fade towards a fringe of light and of the thousand hues of chiaroscuro that appropriate lighting makes possible, it is difficult not to think of the contemporary experiments of the *Mona Lisa,* the lost *Leda,* and the *St. Anne* (as above). The scientific approach tends to establish the validity of the new painting technique.

The most remarkable passage in Codex Madrid II is probably that in which the phenomenon of *lustro,* the reflection of light, is studied: "Luster will take on much more the color of the light that illuminates the reflecting body than the color of that body. And this occurs in the case of opaque surfaces";[48] the hues depend on the nature of the reflecting body. Here Leonardo deals with the point or sheet of light that is reflected on smooth and polished surfaces. This is one aspect of what is called *riverberazione* in Manuscript A. Properly speaking, *lustro* is separate from reflection (*riflesso*) in which a specular image is produced. This is important insofar as it involves the transfer of a neighboring color on the local tint of a given object. The indirect reflections imbue the shadows with shimmering and accidents which, all things considered, are not desirable.

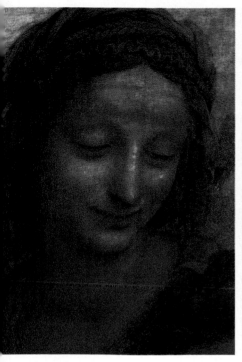
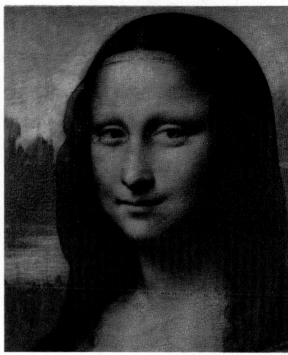

One of the last notes of Codex Madrid II concerns the harmony of the shadows with the lights that are associated with them and recommends that the artistic "compromise" be found and that, for example, "to the shadows of green bodies green things" must correspond.[49] This is to avoid disturbing contrasts caused by the repercussions of *lustro,* which emphasizes the relief but blurs the color. Leonardo's practice is in accordance with these principles. But the observations of Codex Madrid II bear witness to a new interest in these problems. Leonardo seeks not only to justify his own procedure; his insistence seems to imply the taking up of a definite position with regard to the Flemish experiments. It was impossible for Leonardo to ignore the beauty of the pictorial material of the Northern artists and the originality of a style that paid particular attention to irradiations, to the accidents of *lustro,* and to the surprising plays of *riflessi.* The text of Codex Madrid II shows that he perfectly understood their mechanisms, but he was in no way anxious to adopt them. In this he is unquestionably faithful to the Southern attitude, which is more attentive to the fullness of forms in space than to the scintillation of light and the vividness of textures.[50]

171

This study – treating the profile of a man as
if it were a mountainous landscape –
demonstrates the varying effects of light
from a single source striking the face. The
little diagram at left and the notes
immediately above and below it relate to the
action of light within a room. Above those is
a note of advice on composing "a historical
picture." WINDSOR 12604

When you
compose a historical
picture take two points,
one the point of sight,
and the other the source
of light; and make this as
distant as possible.

Shows how light from
any side converges to one
point.

I will make further mention
of the reason of reflections.

Where the angles made by the lines
of incidence are most equal
there will be the highest
light, and where they
are most unequal it
will be darkest.

Although the balls a b c
are lighted from one window,
nevertheless, if you follow
the lines of their shadows
you will see they intersect
at a point forming the angle n.

Since it is proved that every definite light is, or seems to
be, derived from one single point the side illuminated by
it will have its highest light on the portion where the
line of radiance falls perpendicularly; as is shown
above in the lines a g, and also in a h and in l a; and
that portion of the illuminated side will be less lumin-
ous, where the line of incidence strikes it between two
more dissimilar angles, as is seen at b c d. And by this
means you may also know which parts are deprived of
light as is seen at m k.

174

We thus see how the relation of theory to its application becomes established for Leonardo. In the study of reflections and the dialectics of light and shade, the procedure is the same as in anatomy. By identifying unacceptable fading of the local tint and harsh contrasts of light as well as display of musculature, Leonardo was able to avoid the pitfalls.

The general policy of the *Treatise* is then clearly indicated by the notes of Codex Madrid II, where the tendency towards a didactic work becomes manifest: the analyses reveal the *possible* methods of painting, which were not all to be adopted by Leonardo in his own work. We note with pleasure the charming and previously

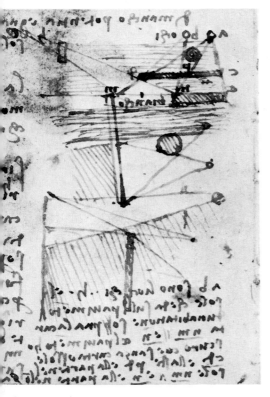

These studies from Codex Madrid II are demonstrations of the effects of light. Left: on folio 23 verso, Leonardo sketches an experiment, showing the sun, eyes, paper, and a board, to prove his point: "A dark object, seen against a luminous background, will appear much smaller than when seen against a background darker than itself." Right: on folio 71 verso, he diagrams outdoors light rebounding off the pavement and striking a face.

unpublished note contained in the Madrid manuscript, "As the sun was declining, I saw the green shadows of the ropes, mast, and yard cast upon a white wall."[51] But this lingering observation does not make Leonardo a precursor of impressionism. For the phenomenon is not considered "pictorial," and if it were, it would not belong to Leonardo's painting.

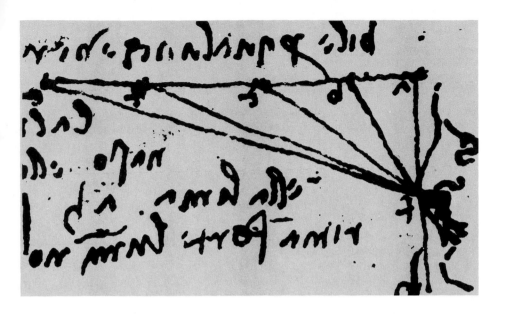

Sfumato ("soft, shaded"), a term that had not yet appeared, was now Leonardo's reply to the whole of pictorial problems. His method was opposed, in a way, to all existing practices. The effects of the irradiation of light, where the Flemish were past masters, were not lost, but the poetics of numerous reflections and brightened colors were to be put aside in favor of infinitely delicate ranges of colors. Relief as practiced by Masaccio, who defined the form from a constant order of light and dark colors, was maintained, but with a deliberate softening of contours, making new liaisons possible between the foreground and the background. A general toned-down key is at the same time the condition and the consequence of the new style. In order to enhance its possibilities in the realm of values, the painting must reduce the height of the tones.

The notes of Codex Madrid II do not then include any great doctrinal developments, but they show how Leonardo, like a chess player carrying on several games at the same time, advanced certain concrete problems and specified certain demonstrations within an important match he was playing. He was conscious of the fact that all these analyses of natural phenomena and these explorations of the living organism took him far away from the practical requirements of the *Treatise* and that it would be necessary to disassociate himself from the analyses. He realized that the development of his speculations led him to statements that would seem like theoretical detours away from the specific problems of the *Treatise*. He

In Codex Madrid II Leonardo takes up the question of lustro – the reflection of light. On folio 26 recto he writes:

Luster will take on much more the color of the light that illuminates the reflecting body than the color of that body. And this occurs in the case of the opaque surfaces.

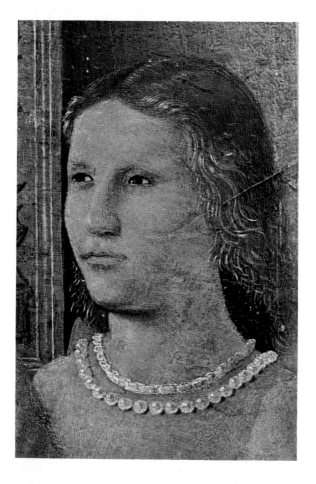

Renaissance painters differed on the use of reflections in their work. The angels shown on these four pages represent four approaches. The angel of Piero della Francesca (left) has no real reflections. The angel at right, by the Flemish painter Gerard David, illustrates the Flemish tendency towards strong reflections from eyes, lips, and jewels.

178

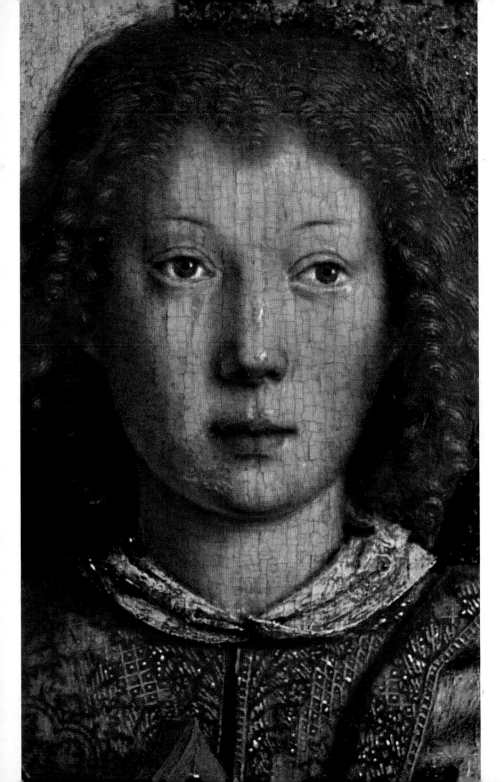

In his angel (below), Piero di Cosimo
imitates the Flemish style but adds simple
shadows on the face. Leonardo was
intrigued by the Flemish use of reflection
but wanted to avoid the harsh contrasts.
His solution gives the illusions of indirect
bounced light, such as that used by photog-

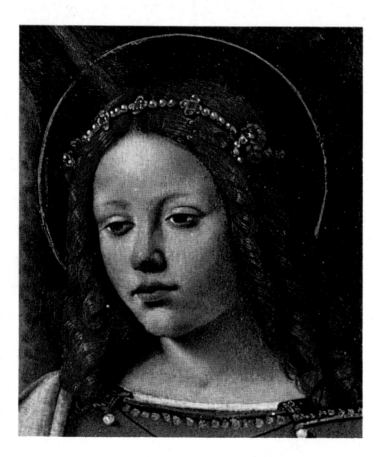

raphers today. The result – as shown at
right in the angel from the Virgin of the
Rocks of the National Gallery, London – is
an intricate, complex play of shadow and
light that restores to the angel her ethereal
mystery. Leonardo's art builds upon science
but transcends it to achieve grace,
ambiguity, and beauty.

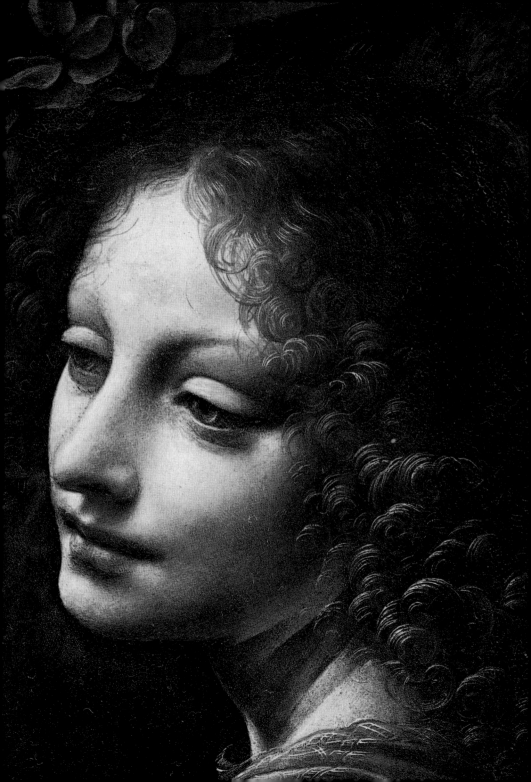

wrote, for example, on the subject of a demonstration of optics, "Although this case cannot be listed among the precepts of painting, I shall not omit it, because speculators may find it useful."[53] And again, "Although such speculations [on the eye] are not needed by the practitioners, I deem it convenient to put them forward because they are often received with admiration by speculative men of talent."[54] In short, the preliminary study of the mechanism of sight seems to banish the positive conclusions that are expected of the theoretician, but it maintains the intellect and the imagination in a sort of exalted vigilance, which is also one of the purposes of the *Treatise.*

We see in what way Leonardo has finally withdrawn from Alberti. The latter recommended to the painter a good education for the arrangement of the *storie* and a knowledge of geometry in order to give exact structure to the compositions. Leonardo reversed the terms: painting coincides ideally with the integral knowledge of nature; and without an all-embracing intuition, which analyses will never be able to detail completely, nothing valid can be achieved. Whence the new character of the discourse on art: it was no longer defined by the humanist framework; this would have subjected the *Treatise* too narrowly to the literary models whose pertinence had been rejected in the *Paragone,* the comparison of poetry and painting.

The ideas of the thinkers who wrote these treatises were known to Leonardo – though not all uncritically accepted – when he was at work composing his Treatise on Painting. Shown on opposite page: Gauricus on sculpture, 1504; Alberti on architecture, 1485. Above left, Alberti on architecture, 1550; left, Alberti on painting, 1547; above, Pacioli on geometric proportions, 1499.

FOOTNOTES

THE PAINTER

1 W. M. Ivins, Jr., *On the Rationalization of Sight,* The Metropolitan Museum of Art, Paper no. 8, New York, 1938.

2 *Leonados Visionen von der Sintflut und vom Untergang der Welt* (Bern, 1958).

3 Leonardo da Vinci, *Treatise on Painting* (Codex Urbinas Latinus 1270), translated and annotated by A. Philip McMahon (Princeton, 1956), pp. 9, 30−31.

4 Fols. 101v and 102r and v.

5 For instance, in the three lower figures of fol. 63v.

6 Fols. 30r, 49r, 54r.

7 Codex Urbinas Latinus 1270.

THE SCULPTOR

1 Vannoccio Biringucci, *Li dieci libri della Pirotechnia* (ed. 1550), p. 82r; Giorgio Vasari, *Le Vite* (ed. Milanesi), vol. I, p. 158 ff.; Benvenuto Cellini, *I trattati della oreficeria e della scultura* (ed. Firenze, 1857), p. 164 ff.; Germain Boffrand, *Descriptio omnium Operarum Quibus ad Fundendam ex Aere Una Emissione Metalli Ludovici Decimiquarti Statuam Equestrem...*(Paris, 1743), p. 29 ff. I am indebted to the late Dr. Ladislao Reti for bringing Boffrand's work to my attention.

2 The letter was published by Luca Beltrami in *Il Castello di Milano* (1894), p. 314. It was therefore known to Leonardo scholars; nevertheless, it is G. Castelfranco, *Storia di Milano,* vol. VIII, p. 511, that we must thank for not having overlooked the important reference to a life-size monument.

3 Codex Atlanticus, fol. 39lr-a.

4 For instance Windsor 12357 and 12358r.

5 Windsor 12349r.

6 Codex Atlanticus fol. 148r-a is dated 1487 by C. Pedretti, *A Chronology of L. da Vinci's Architectural Studies after 1500* (Geneva, 1962), p. 61; it is dated ca. 1490 by L. Beltrami, *L. da Vinci negli studi per il tiburio...*(Milan, 1903), and by L. Firpo, *Leonardo architetto e urbaniste* (Turin, 1963), p 136. It may de added that the base and pedestal sketched on fol. 148r-a find analogies with some of the studies for the Trivulzio equestrian group; see Windsor 12353.

7 The letter was published by G. Poggi in *Leonardo da Vinci: Vita di G. Vasari commentata ...*(Florence, 1919), p. 23 ff.; on the same subject, see Castelfranco, op. cit.

8 Manuscript C, fol. 15 v.

9 Windsor 12345. This drawing is a fragment of fol. 147r-b of the Codex Atlanticus. Leonardo's presence in Pavia with Francesco di Giorgio Martini is recorded in 1490; see G. Calvi, *Archivio storico lombardo,* vol. XLIII, 1916, p. 468.

10 On the Regisole of Pavia, see especially L. Heydenreich's study "Marc Aurel u. Regisole" in *Festschrift für Erich Meyer* (Hamburg, 1959), p. 146 ff.

11 Paolo Giovio, *Leonardo Vincii vita;* see recent anthology by R. Cianchi in *Raccolta Vinciana,* fasc. XX, 1964, pp. 288−289.

12 See Windsor 12294 and 12319.

13 In his painting "The Hunt of Meleagro" kept in the Prado Poussin exemplified the various types of horses studied by Leonardo. We are thankful to Xavier da Salas for drawing our attention to this interesting document confirming Poussin's deep knowledge of Leonardo's drawings. On this see also J. Bialostocki, "Poussin et Léonard," in *Colloque Nicolas Poussin,* vol. I (Paris, 1960), p. 133 ff.

14 The horse of Marcus Aurelius can be compared here: originally the forehoof was resting on the figure of a barbarian in subjection. See K. Kluge − K. Lehmann Hartleben, *Die antiken Grossbronzen* (1927), vol. II, p.

85; P. Ducati, *L'Arte classica* (ed. of 1956), p. 671.

15 Ph. Argelati, Bibliotecha scriptorum mediolanensium...premittitur Joseph Antonii Saxii Historia Literaria − Typographica Mediolanensis, ab anno MCDLXV ad annum MD...ed. Mediolani 1745, vol. I, col. 356.

16 Paris, Bibliothèque Nationale 3141, Manuscript Italien 372. This manuscript, which deals with the history of the Sforza family, was first mentioned by Rio, *L. da Vinci e la sua scuola* (ed. of 1856), p. 30, in relation to the monument of Francesco Sforza, and most recently by K. Clark, *The Drawings of Leonardo da Vinci at Windsor Castle,* 2d ed. revised with the assistance of C. Pedretti, vol. I (London, 1968), p. xxxvii, note 1.

17 Fol. 148r, par. 2.

18 *De divina proportione,* 1497 (Vienna ed. of 1896), dedicatory page to Lodovico Sforza.

19 Paolo Cortese, *De cardinalatu* (1510), line 1, p. 50 (published in G. Tiraboschi, *St. d. lett. italiana,* t. VI, part V, p. 1599); Paolo Giovio, op. cit. (published in G. Tiraboschi, t. VII, p. 1718 ff.); Matteo Bandello, *Le Novelle* (ed. of 1910), vol. II, *Proemio alla novella,* n. 58.

20 Fol. 320r-a.

21 Theophilus, *Diversarum artium schedula,* edited by W. Theobald (Berlin, 1933); on casting see especially 1, III, chaps. XXX and LX. This work contains the first written description of the lost-wax casting system still in existence.

22 Pomponio Gaurico, *De sculptura* (ed. 1542), p. 37 ff. See also Pomponius Gauricus, *De sculptura,* annotated by A. Chastel and R. Klein (Geneva-Paris, 1969), chap. VI, p. 209.

23 Codex Madrid II, fol. 151v, where Leonardo declared, "I have decided to cast the horse without tail," thereby confirming his intention to cast the horse in one piece.

24 Folios 12350 and 12347r from the Windsor Collection contain short notes about the casting procedure described in Codex Madrid II: cf. M. V. Brugnoli, Documenti, notizie e ipotesi sulla scultura di Leonardo in

Leonardo saggi e ricerche (ed. Roma, 1954), p. 368 ff. Not all scholars agree that Windsor 12347r is datable from the period of the Sforza monument: nevertheless such a date really seems to be confirmed by Codex Madrid II (type of pacing horse from folio 149r; note concerning "the mold of the horse" nearly identical in Codex Madrid and on Windsor 12347r).

25 In Windsor 12347r.

26 Fol. 396v-c.

27 Fol. 142r, par. 3. It is interesting to note that neither Vasari nor Cellini mention this process, while Germain Boffrand describes it in connection with the casting method applied for the colossal equestrian monument to Louis XIV.

28 Fol. 144v, par. 3.

29 Fol. 352r-c, datable to 1490.

30 Codex Atlanticus, fol. 179v-a: "to make the mold of clay and then of wax."

31 Codex Madrid II, fol. 148v, par. 3.

32 Codex Madrid II, fols. 145r, par. 1, and 143r, par. 2. Cf. also Windsor 12350.

33 Vannoccio Biringucci, op. cit., p. 90r. See also Codex Trivulzianus (ed. Milano, 1939), fol. 16r.

34 Codex Madrid II, fol. 144v, par. 2.

35 Codex Madrid II, fol. 147v, par. 2.

36 See Biringucci, op. cit., p. 90v: "Re-baked earth breaks easily and is difficult to repair once it has broken."

37 Codex Madrid II, fol. 147r, par. 1.

38 See the drawing on Windsor 12348.

39 Codex Madrid II, fol. 147v, par. 1.

40 An accurate transcription of the duke's letter was given by C. Pedretti, *Leonardo da Vinci a Bologna e in Emilia* (Bologna, 1953), pp. 151–152. Clark, op. cit., 1968, p. 23, note to 12321, underlines that in this letter it is not the model, but the mold of the horse that is requested.

41 In November 1494 Il Moro handed over the metal intended for the casting of the Sforza horse to Ercole d'Este, who sent it to Ferrara. See Marino Sanudo, "Spedizione di Carlo

VIII in Italia," op. cit. in *Raccolta Vinciana*, fasc. XIII, p. 83.

42 Codex Atlanticus, fol. 335v-a datable about 1497.

43 Codex Madrid II, fols. 145r, par. 3 and 151v.

44 Codex Madrid II, fols. 149r and 141v, par. 2.

45 Cellini, op. cit., p. 225. This work was first published in 1568.

46 Boffrand, op. cit.

THE TEACHER

NOTE: The author of this chapter discussed the relation between Codex Madrid II and the *Treatise on Painting* also in "Les Notes de Leonardo de Vinci sur la peinture d'après le nouveau manuscrit de Madrid," *Revue de l'art,* no. 15, 1972.

1 In order to place the enterprise of the *Treatise on Painting* into the frame of the epoch, it is always necessary to consult J. Schlosser, *La Letteratura artistica* (first published in 1924, Italian ed. 1935, re-ed. Florence, 1956) and A. Blunt, *Artistic Theory in Italy 1450–1600* (Oxford, 1940, re-ed. 1956).

2 The chronological classification presented by A. M. Brizio, *Scritti scelti di Leonardo da Vinci* (Turin, 1952) reveals the technical nature of Leonardo's first writings (ballistics), and his philological (studies on vocabulary) and literary (fables) exercises.

3 He then tabulated all the different parts down to the smallest veins and the composition of the bones with extreme accuracy in order that this work on which he had spent so many years should be published from copper engravings for the benefit of art. Text in J. P. Richter, *The Literary Works of Leonardo da Vinci,* 2d ed. (London, 1939), vol. I, p. 3.

4 Edition procured by Domenichi at the publisher Giolito's. The work is dedicated to Salviati, a fact which is not without interest. His friend, Doni calls his attention to it in a letter of June 3: "I have also seen Leon Battista Alberti's book on painting, translated by Domenichi and dedicated to you"

Letter quoted in A. F. Doni's edition of Mario Pepe *Disegno* (Milan, 1970), p. 109.

5 J. Schlosser, *La Letteratura artistica*, Italian translation, 2d ed. (Florence, 1956), p. 126 ff. (the editions of Alberti), p. 251 ff. (the Vitruvian studies).

6 See A. Chastel, "Léonard et la culture," in *Léonard de Vinci et l'expérience scientifique* (Paris, 1963).

7 See E. Panofsky, "Artist, Scientist, Genius," in *The Renaissance: A Symposium* (New York, 1952).

8 L. Olschki, *Geschichte der neusprachlichen wissenschaftlichen Literatur,* vol. I, *Die Literatur der Technik* (Leipzig, 1919).

9 On the 2d of April 1489, book entitled "Of the human figure" Windsor 19059, and all the passages in A. M. Brizio, op. cit., p. 153.

10 Edition of C. Winterberg (Vienna, 1889), p. 33.

11 C. Pedretti, *Leonardo da Vinci on Painting: A Lost Book (Libro A)* (Berkeley, 1964). On the long elaboration of the *Treatise,* see the introduction to the Pedretti work, the introduction to Richter, op. cit., L. H. Heydenreich's introduction to the Princeton edition of the Codex Urbinas (1956).

12 Br. M. Ia, in Richter, op. cit., p. 112, no. 4.

13 "The years 1505–1508 represent a crucial point in the development of Leonardo as a theorist of art." Pedretti, op. cit., p. 20, note 32.

14 Fol. 15v.

15 Fols. 23v-28v, 70v-78v, and 125r-128r.

16 It is, howeyer, difficult to specify the recording of the Madrid manuscript in the list carefully established and presented by Melzi; see Pedretti, op. cit., app. I, p. 229 ff.

17 These connections with the Codex Urbinas have been closely examined in Pedretti, *Le Note di pittura di Leonardo da Vinci nei manoscritti inediti a Madrid,* Lettura Vinciana VIII (Florence, 1968).

18 Fol. 15v.

19 J. White, *The Birth and Rebirth of Pictorial Space* (Lon-

don, 1957), p. 207 ff. D. Gioseffi, *Perspectiva artificialis* (Trieste, 1957), C. Pedretti, "Leonardo on Curvilinear Perspective," in *Bibl. Humanisme et Renaissance*, vol. XXV, p. 584 ff., 1963. Final text of Manuscript E, fol. 16v, in Richter, op. cit., nos. 107 and 108.

[20] Fol. 25v.

[21] Fol. 60v.

[22] C. Pedretti, "La Battaglia d'Anghiari," *L'Arte*, 1968, pp. 62−73.

[23] Fol. 78v.

[24] Fol. 128.

[25] A. E. Popham, *The Drawings of Leonardo* (London, 1946), pl. 237. K. Clark, *The Drawings of Leonardo da Vinci at Windsor Castle*, 2d ed. revised with the assistance of C. Pedretti, vol. I (London, 1968−1969), p. 135, suggests for Windsor 12640 possible dating after *Anghiari*, which is difficult to accept.

[26] K. Clark, "Leonardo and the Antique," in *Leonardo's Legacy: An International Symposium* (Berkeley and Los Angeles, 1969).

[27] Fol. 70v.

[28] Fol. 128r.

[29] Fols. 116v-117v.

[30] B.N. 2038, fol. 33v.

[31] Manuscript L., fol. 79r, taken up again in the Codex Urbinas, fol. 118v. See C. Pedretti, *Leonardo da Vinci on Painting*, p. 135.

[32] Fol. 20.

[33] Fol. 71r.

[34] Windsor 19032v.

[35] Fol. 26r. The subject is taken up again in the Codex Urbinas, fol. 117.

[36] Vasari, *Proemio* of the third part. See A. Chastel, *Le grand atelier d'Italie* (Paris, 1965), p. 321 ff.

[37] M. Kemp, "Il Concetto dell' anima in Leonardo's Early Skull Studies," *Journal of the Warburg and Courtauld Institutes*, vol. XXIV, pp. 115−136, 1971. On the subject of the cranial sections of 1489, see Windsor 19057r.

[38] Fol. 26r.

[39] Fols. 25-25.

[40] R. Marcolongo, *Leonardo da Vinci, artista, scienziato* (Milan, 1930), p. 169 ff.

[41] Fol. 71r.

[42] Fol. 70v.

[43] Fol. 26r.

[44] Fol. 25r.

[45] Fol. 71v.

[46] M. Rzepinska. "Light and Shadow in the Late Writings of Leonardo da Vinci," *Raccolta Vinciana*, fasc. XIV, pp. 250−266, 1962.

[47] Codex Urbinas, fol. 40 ff.

[48] Fol. 26r.

[49] Fol. 127v.

[50] L. H. Gombrich, "Light Form and Texture in XVth Century Painting," *Journal of the Royal Society of Arts*, 1964, pp. 826−849. The connections of Leonardo's art with that of the Flemish artiers remain to be investigated, bearing in mind the familiarity of the Italian work with Northern painting at the end of the 15th century and the opposition of the two mentalities. Some indications are given in A. Chastel, *Le grand atelier*, p. 275 ff.

[51] Fol. 125r.

[52] J. Sherman, "Leonardo's Colour and Chiaroscuro." *Zeitschrift für Kunstgeschichte*, vol. XXV, pp. 13−47, 1962.

[53] Fol. 26v.

[54] Fol. 127v.

LIST OF ILLUSTRATIONS

Abbreviations:
a above
b below
c center
l left
r right

INTRODUCTION

THE PAINTER

INDEX